WARWORKS

WARWORKS

WOMEN, PHOTOGRAPHY AND THE
ICONOGRAPHY OF WAR

Val Williams

To Meri and Megan

Published by VIRAGO PRESS Limited, November 1994
The Rotunda, 42-43 Gloucester Crescent, Camden Town, London NW1 7PD

Designed by Lone Morton

A CIP record for this title is available from the British Library

Typeset in Berthold Joanna
Printed in Great Britain by Jackson and Wilson, Leeds, England.

Published with financial assistance from the Arts Council

Contents

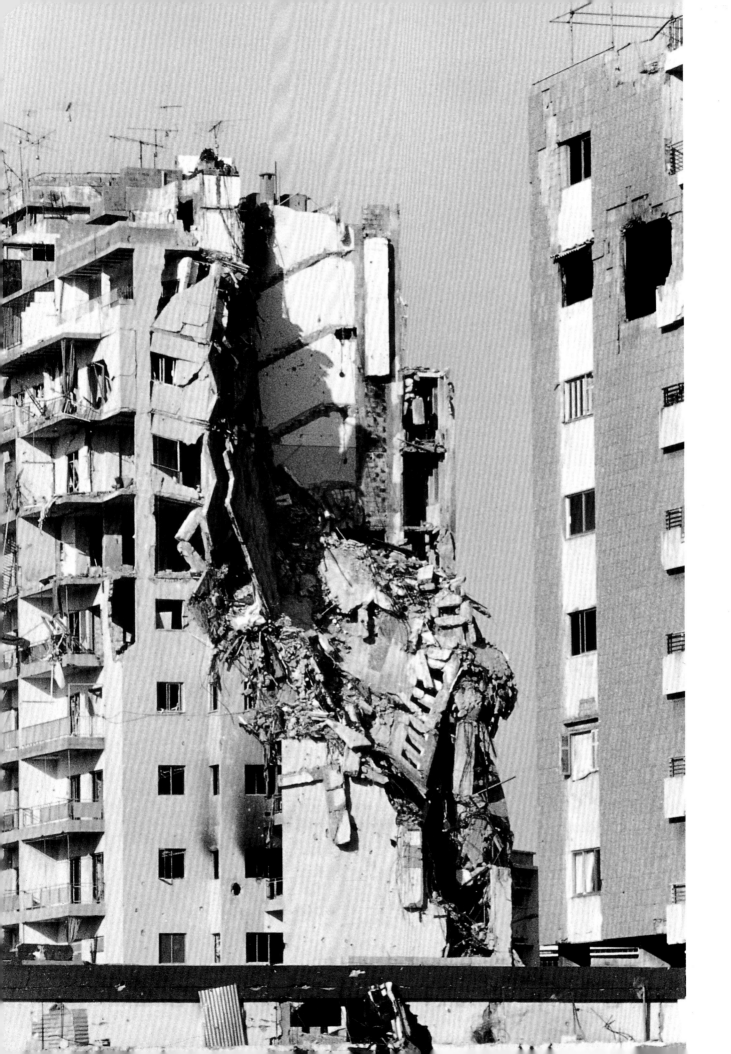

Acknowledgements

For their advice, support and encouragement during the process of research and organization of the *Warworks* project, very special thanks to: David Brittain (Creative Camera, London); Michael Collins; Mark Haworth-Booth (Victoria and Albert Museum, London); Anna Fox; Frits Gierstberg (Foto Instituut, Rotterdam); Linda Lloyd-Jones (Victoria and Albert Museum, London); David Mellor (University of Sussex); Ruth Petrie (Virago Press); Karel Winterink (Foto Instituut, Rotterdam).

The assistance of the following individuals and organizations is also gratefully acknowledged:

Barbara Alper, New York; Ania Bien; Susan Butler; Deborah Bright; Carole Callow (Lee Miller Archive); Jane Carmichael (Imperial War Museum, London); Nancy Clendaniel; Hannah Collins; James Danziger Gallery, New York; Alan Dien; The Edge Gallery, London; Adrian Elligens (Stichtung Fotoarchief, Amsterdam); Helen Ennis; Martin Firrell; Christine Frisinghelli (Camera Austria, Graz); Gabby Glassmann; Marisela le Grave; Barbara Hall; Dominique Hoff (French Institute, London); Rupert Jenkins (San Francisco Camerawork); Al Johnson; David King Collection; Barry Lane (Arts Council of England); Yve Lomax; Constance Stuart Larrabee; Sheila Lawson; Rachel Lichtenstein; Hildegarde Mahoney (Photographers Gallery Library, London); Manchester Jewish Museum; Moira McIver; Hansel Mieth; National Museum of Women in the Arts (Washington, D.C.); Lone Morton; John Morton; Gail Newton (Australian National Gallery, Canberra); Anne Noggle; Martin Parr; Anthony Penrose (Lee Miller Archive); Terence Pepper (National Portrait Gallery, London); Rob Perks (National Sound Archive, London); Sandra Phillips (San Francisco Museum of Modern Art); Judith Joy Ross; Sophie Ristelhueber; Martha Rosler; Amy Rule (Center for Creative Photography, University of Arizona); Leena Saraste; Christine Spengler; Smithsonian Institution Travelling Exhibition Service (Washington D.C.); South Bank Centre, London; Elizabeth Anne Williams (Montage Gallery); University of Leiden (The Netherlands); Trudy Wilner-Stack (Center for Creative Photography, University of Arizona).

The exhibition *Warworks* is previewed at the Rotterdam Photo International from 15-23 October 1994 and opens at the Victoria and Albert Musuem, London where it will show from 11 January until the end of March, 1995. The artists taking part in *Warworks* are: Barbara Alper (USA); Ania Bien (The Netherlands); Deborah Bright (USA); Hannah Collins (UK); Anna Fox (UK); Masumi Hayashi (USA); Moira McIver (Northern Ireland); Anne Noggle (USA); Sophie Ristelhueber (France); Martha Rosler (USA); Judith Joy Ross (USA); Elizabeth Williams (UK). *Warworks* was curated by Val Williams, assisted by Anna Fox. Both the exhibition and the publication are Arts Council funded.

From the series Beirut. 1984. Sophie Ristelhueber. 50cm x 60cm. Courtesy of the artist.

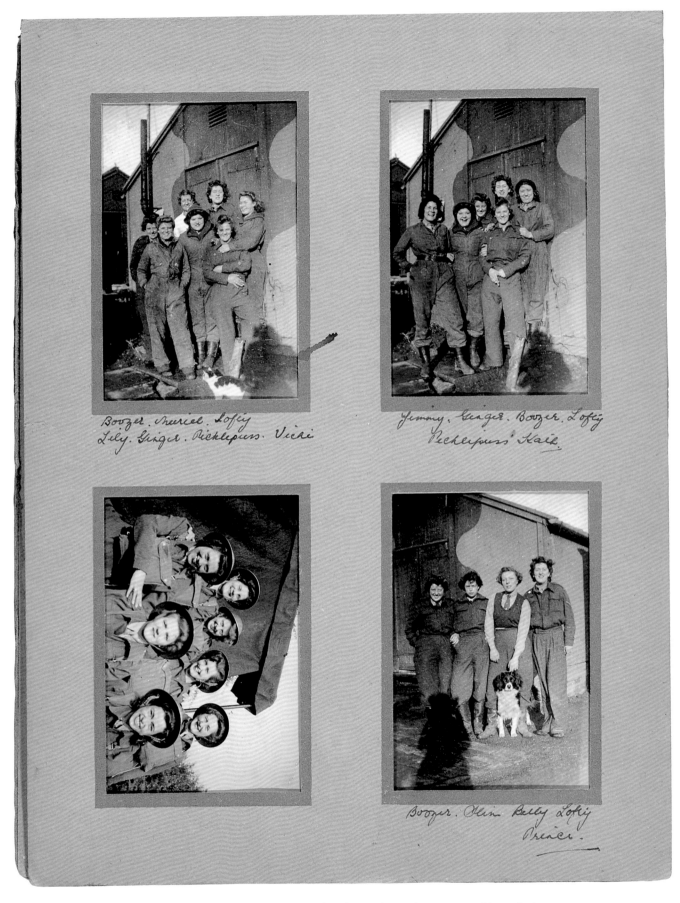

Page from a photograph album of World War Two. 56cm x 42cm. Photographer unknown. Photographs 3.5cm x 4cm. Private collection..

INTRODUCTION
From the Private to the Public:
Photography, Memory and the Iconography of War

Photography, like any other art form, has its great themes. The portrayal of war is one which, since the beginning of the medium, has seized the imagination and engaged the attention of a huge public. From the Crimea to the Gulf, photographers have felt impelled to make records of crises, and we, as audience, have relied on this imagery to inform us of world events. But photography, partial as it is, and possessed of a myriad of aesthetic devices, is more than information. It is a kind of propaganda, whether personal or political, and persuades us to see the world in a very particular way.

At times, photography appears to provide us with a picture of the 'real world' and, convinced by its virtuosity, we are inclined to believe the photographer's view of events. Few of us have any real experience of the war zone. Our comprehension of war comes instead from what we have read and what we have seen in photographs transmitted by photojournalists from distant places or on the television screen. What we make of war emerges from our memories of words and images constructed for us by a hugely diverse collection of journalists, photographers, filmmakers and artists. The 1993 film *Schindler's List*, made by Hollywood director Steven Spielberg, will undoubtedly remain in the minds of its massive and ever-growing audience as a major representation of the events of the Holocaust. Yet, for all its painstaking accuracy, it remains a construct, built up from the recollections of survivors, from accumulated documentation collected after the end of the Second World War, from photographs made at the time, documentary film and a mass of other evidence. Most of those who see *Schindler's List* will have no first hand experience of the events of the Holocaust; they will rely instead on the collective European memory of this great tragedy to provide them with a framework within which they may view the film.

Warworks is, in many ways, a book about memory. It explores the ways in which photography is able to fill vacuums within our own experience, to provide us with an historical framework without which we would be unable to assess the state of our society, to make judgements on world events, to place ourselves as component parts within a shifting and

bewildering whole. Photography is not, of course, the only enabler in this complex process, but it is one of the most potent. Photography has a meaning for us all; it is prolific and accessible, a still and silent provider of information and a channel for our own imaginations. It is a seductive, compelling and sometimes dangerous medium which, ironically enough, we all take for granted. Memory is both selective and wilful. Images of the concentration camps of the Second World War, glimpsed in history books or flashed for a moment on the television screen, remain in the mind like unwelcome demons. We store memories, only to alter and revise them to fit personal schemas. Important details and insignificant facts are all subject to the process of the passing of time, and even photographs, stern reminders of chronology and event, can be challenged. A family snapshot, taken in the minute before the sun went in and an argument erupted, is a very unreliable piece of evidence, a very partial history. Photography tells us not only about what the world looks like, but also something of what it means; photographs present a mass of opinions, governed by individual predelictions, by cultural background and by experience. As a witness of war, photography's status is assured, but the role and veracity of the witness is always open to question.

When we think of war photography, it is usually reportage which comes to mind. We are surrounded by imagery of war, in the press, on television and in films which constantly reinterpret and represent past conflicts. Through these media, the war photojournalist has become a recognized and sometimes legendary figure. Indeed, so much has been written about war reporters and their photographs, that at times, the work begins to parody itself.

War photoreportage, though always a presence in this book, does not form its core. Rather, I have considered other kinds of photography – work produced by artists over the last two decades, family portraits, guide book illustrations and photo series which question the very nature of reportage. Many of the photographs and artworks which I have included explore notions of photography and memory, both collective and personal, public and private. These essays aim to ask questions rather than to supply answers.

As a child of the immediate post-war years, my first memories of war came from my family, and from the place where I was born. Coventry, an industrial conurbation in the West Midlands, was bombed heavily by the German airforce during World War Two. Thousands were killed and injured, and the mediaeval centre of the city was almost completely destroyed. My mother, as a young woman, had stood in her home town of Leicester, some fifty miles away, and watched Coventry burn. During my childhood, Coventry was rebuilt, not always beautifully, but with hope and optimism. The city centre shopping precinct was a model of modernity, and, not aware then of the collective follies of modern architecture, we were proud of its pristine pavements and its traffic-free spaces. Though surrounded with evidence of the bombing and the reconstruction which followed it, as children we had very little interest in the war. Coventry was a prosperous city then, riding high on the motor industry and the satellite services which fuelled it. As the generation which was to reach adolescence in the 1960s, we were glad to see the back of the old; the despoiling of a mediaeval city meant little to us.

*Three WAAF nurses, circa 1942.
Frances Williams is pictured
standing behind two friends.
Snapshot. Photographer unknown.
3"x 5". Private collection.*

My first memories of the Second World War came from my mother, who had been a nurse in the WAAF. As her youngest child, and only daughter, I became caught up, perhaps a little unwillingly, in her recollections of life in the 1940s. For my mother, the war was a time of both opportunity and grief. Her first husband, a bomber pilot in the RAF, was killed in a raid over Europe. My mother, married to him for only a short time, had kept his pilot's insignia, a pair of cloth wings, as a remembrance. Every so often, she would take them out of a small box, kept in a drawer, and show them to me. Though I am unable to remember what she said about them, I am still aware of the tremendous importance they held for her, as a receptacle of memory, a symbol of loss.

My mother's memories of the war were selective, a mixture of recollections of exciting times on slow trains travelling the length and breadth of Britain, and gruesome days and nights caring for pilots whose bodies were still burning when they were brought into hospital. Why my mother shared these memories with a small child is a puzzle – perhaps I was a captive audience in a disinterested world, or perhaps she thought that I should know. It brought us closer together, and for many years I felt a co-conspirator in the world of her lost dreams and regrets.

My inherited childhood memories of the war were women's memories. For me, the war was a time in which women, symbolised by my mother, had not only suffered, but also triumphed. They had escaped, if only for a few years, from the narrow confines of home and family and ventured out into the real world of action and adventure. It was my earliest realization that women could have dynamic lives, could gain some kind of empowerment.

As a teenager, I encountered the war in Vietnam, not through the memories of my family,

but through the flickering black and white screen of our very first television. Vietnam did not engage my attention, and world news held little interest. Though I grieved when I saw the news reports of the engulfing of a primary school by a massive coalslip in the Welsh mining village of Aberfan, the sufferings of the children of Vietnam hardly impinged on my consciousness.

As a literary, rather than a visual, nation (at least in the 1950s and 1960s), teaching about war was centred on written accounts rather than on the work of photographers or painters. At school we read Siegfried Sassoon and Wilfred Owen and were much impressed by Robert Graves' chronicle of the First World War, *Goodbye to All That*. At home we watched *The Dambusters* and *Bridge over the River Kwai*, but no one told us about the pacifist Vera Brittain, or the women of the French Resistance. The Nazis were all men, and no one recounted the stories of Irma Griese, or the Nazi propagandist filmmaker Leni Riefenstahl. This history appeared to be a very male one, a conglomeration of uniforms and weaponry, an uneasy mixture of guilt and

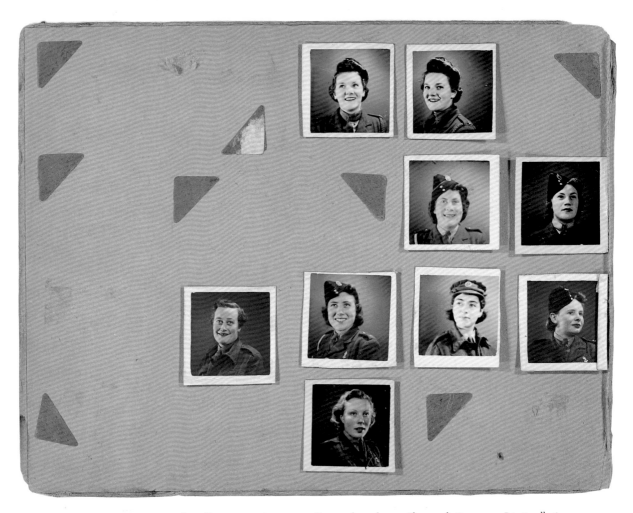

Page from a photograph album of World War Two. 56cm x 42cm. Photographer unknown. Photographs 8cm x 5cm. Private collection.

aggression. In the playground at school the boys would play Nazis and Englishmen when they got tired of cowboys and Indians, while we pretended to be princesses or nurses. When the boys hit us, we cried and told the teacher, pacifists to the last.

Evidence of war photography was scarce in the post-war years. *Picture Post*, the mass circulation magazine which had flourished in Britain during the Second World War, closed in 1957. By the time that photographic publishing had begun to reassert itself in the mid-1960s, the Second World War was an old story. Only in the 1970s, when photographic books began to flood a hungry market, did photographic historians and photographers begin to look closely at the iconography of war. Another set of memories, often those of photojournalists, began to imprint themselves on our minds. Divorced from their original context of magazines and newspapers, photojournalism and humanist photodocumentary began to occupy that uneasy position in our aesthetic consciousness which lies midway between art and information. Through the eyes of the great photojournalists who had documented World War Two, we began to recognize the appearance of war, and those appearances were dramatic, beguiling and full of aesthetic device.

Through photoreportage, war itself becomes a construct, a compilation of visual information which must answer the expectations of a waiting public. When we see a photo-story about war, we subliminally anticipate a number of visual elements – a dead body, an anguished family, a destroyed building, a distraught child. Without these indicators of what a photograph is, and what it means, we might be disappointed, unable to feel guilt or compassion, deprived of catharsis.

Humanist photography, a vital component of photojournalism, presents us with scenarios which we can believe in – well-formed constructions to which we can relate as we would to a beautiful painting, a well-designed building or an attractive face. It also provides us with a vocabulary of opposites. Sitting in our gardens scanning the weekend picture magazines we can be aware of our own good fortune – we are at peace, these other people at war, our children are safe, theirs endangered. The media provides us with a rich diet of wars in distant places. Domestic conflicts remain more obscure. Our own British war, in Northern Ireland, is largely hidden from our gaze, too close to home, too near for comfort. Humanist photojournalism is almost always constructed by professionals, men and women who have learned the art and craft of photography. We are able to rest assured in that professionalism, to trust in their expertise.

At its inception, the schema of this book was quite simple – to research and document the lives and careers of women war photographers and to place them in an historical context. But a subject such as this goes beyond mere chronology, and defeats the historian's careful weighing of chronologies and aesthetic considerations. Histories of women's work are often merely mainstream reinterpretations of a male tradition, their gender bias facile and without meaning. Luminary figures such as Margaret Bourke-White and Lee Miller have already featured extensively in biographies, autobiographies, television programmes and exhibition catalogues.

I believed that somewhere there was another history, more relevant than this much-told one. I discovered other, less familiar photo documentarists, such as German-born Hansel Mieth and the South African photojournalist Constance Stuart Larrabee, both of whom were active as reporters in the 1940s, but interesting as their work was, it did not seem to set another agenda for a new history. The gender divide which I had set for this book began to seem irrelevant if it were not able to establish a different approach to the nature and importance of war photography. For many women, received history jars with their own experience, making their own histories seem irrelevant or even wrong. I wanted to make those histories relevant, to take them out of the arena of personal lives and to re-situate them in an area of public memory. And yet histories of women's work are often seen as 'alternative' to a mainstream, traditionalist view. So it is important to stress that, although most of the work discussed here has been made by women, it has been selected not because it provides an alternative, but because of its directive and innovative quality.

The coming of postmodernism to art and photography in the mid 1980s changed the way we look at images. What had seemed so certain in the 1970s now looked to be in disarray. The traditional formalist canons of excellence, together with the curatorial and establishment structures which supported them, began not so much to topple as to waver. Women, whether working in photography or in fine art, have been highly active within a postmodernist culture, in new thinking and new methodologies of seeing. Policies of equal opportunity, though often inadequate, resulted in the need for the Establishment to recognize that not only was it obligatory for women's work to be recognized, but also that political correctness could be exciting. Though curators of major photography exhibitions in Britain (the major *Art of Photography* show at the Royal Academy in 1989 is an example of curatorial chauvinism particularly worth noting) still made their selections of women's work on the basis of tokenism, smaller, but nonetheless influential galleries and institutions began to exhibit work by women as a matter of course and without attention to their gender.

With modernist models displaced, postmodernist artists working with photography began to look more closely at the signs and symbols contained within the photographic image, and to consider how these related both to the subject matter and to a wider history. Artists such as Deborah Bright in her *Battlefield Panorama* series could look again, and closely, at the emotional and poetic framework in which photographers have enclosed landscape, while documentarists such as Anna Fox, in her photographs of weekend war games in the South of England, used photoreportage to subvert itself. In Northern Ireland, Moira McIver looked at men in uniform, exploring the fantasies engendered by flesh against cloth, making use of the eroticist's device of obscuring the face and fetishizing the anonymous body not of a soft porn female model, but of a Falklands veteran.

In the heart of Manhattan, Barbara Alper photographed subtitled TV news reports throughout the Gulf War and became fascinated by the uneasy juxtaposition of image and text. Japanese-American artist Masumi Hayashi visited the now derelict internment camp in Arizona

where she was born and, from its rotting concrete and broken beams, constructed her own fable of time and recollection. Her journeys to these internment camps were a search for family and lineage as well as an exploration of a contentious national issue. Ania Bien, living and working in Amsterdam, created, in her piece *Hotel Polen*, a document which, though referring obliquely to the Holocaust, is ultimately concerned with the rite of passage which art can become.

The work of these artists demonstrates that the photography of war need not be connected with photoreportage. It shows that to photograph war one does not have to be in a battle zone; nor does the appellation of witness always belong to the contemporary observer. As the blanket of censorship (and the even more dangerous one of self-censorship) descends more heavily than ever on the press in time of war, many artists have found another way to record: they have used memory and narrative, explored notions of sexuality and fantasy to both subvert and explain this most male of subjects.

History brings us into contact with the living and the dead, the past and the present. Young East End artist Rachel Lichtenstein, contemporary citizen of a modern world, has made her own very personal odyssey into the phantasmagoria of the Holocaust. Surrounded by the growing racism and intolerance of Europe in the 1990s, work like hers has a special contemporary relevance. Looking through Rose Coombs' *Guide to the Battlefields of Europe*, one must acknowledge that the First World War has become not just a political and social tragedy, but also a part of the heritage industry and a site of spectatorship. Anne Noggle's portraits of her fellow World War Two women pilots are about the phenomenon of growing old, just as much as they are concerned with wartime memories.

Seen through these bodies of work, the connection between the private and the public, between the present and the past, is a subtle and eerie one. Swept into other people's histories, one becomes more conscious of one's own; of the presence of ghosts, knocking at the door of memory and demanding to be let in.

LANDSCAPE REVISED
The Rural Iconography of the First World War

Every war has its prevailing motif. The First World War (1914-18) has remained potent in the collective memory of the western world. Its devastation, the death of men on an unprecedented scale, its combination of brutality, mismanagement and the overwhelming evidence of class distinction in Edwardian Britain, together with a disintegrating and increasingly desperate imperialism, provoked a public memory of warfare which informed generations to come.

From the Holocaust of the Second World War we retain the visions of the Nazi camps – bleak railway lines leading to apocalypse, piled corpses, mass murders. World War Two is a crowded canvas of bodies and buildings, of vehicles and weapons, a scenario crowded with people, against an urban backdrop. Thinking about the war in Vietnam, we remember the viridian green of the jungle and the lumbering helicopters, viewed via the television screen. The perceptions of war by those who have not been in combat are complex and often ambiguous.

Culture has espoused war as a major topic, and significant canons of aesthetic interpretation in literature, film and the visual arts have emerged throughout the twentieth century. The contribution of women writers and artists to our collective remembrance of World War One provides an important register for women's experience of the conflict. Vera Brittain's autobiography of the First World War, *Testament of Youth* (1933) has become a touchstone of the frustrations and bitterness of Edwardian women emanating from a war which decimated a generation and, though contributing to women at last winning the right to vote in 1918 and giving some a temporary independence through war service, left many with immense feelings of powerlessness.

When Brittain returned from her first tour of duty as a VAD in Southern Europe, she asked to be posted to France. After her arrival in Etaples, she travelled by train across the French countryside. It is her memory of this landscape which she tried to decipher over a decade later in her autobiography. The comparisons she made between the land in wartime and in

From The Battle of the Somme, *a section from* Before Endeavours Fade: A Guide to the Battlefields of the First World War *by Rose E.B.Coombs 1976/1990.*
'*Even after nearly sixty years of ploughing, the trenches of the Schwaben Redoubt are still visible from the air. Inserts: The 36th Division Memorial (top left) and the Mill Road Cemetery (bottom right) both visible in the aerial photograph*'.
Courtesy of Battle of Britain Prints International Limited.

peacetime are significant:

> Today, when I go on holiday along this railway line, I have to look carefully for the place in which I once lived so intensely. After a dozen almost yearly journeys, I am not sure that I could find it, for the last of the scars has disappeared from the fields where the camps were spread, the turnips and potatoes and mangel-wurzels of a mild agricultural country cover the soil that held so much agony. Even the weather-beaten crosses, with their bright gardens of pansies and stocks and marigolds, in the big cemetery below the pinewoods at the top of the hill have been replaced by the stone architecture of our post-war frenzy for memorials ... Only the sandhills and the sea remain unchanged.[1]

Many historians have noted the importance of the land for the diarists, poets and letter-writers of the First World War. Many women, especially city-dwellers (such as the studio photographer Madame Yevonde) who joined the Women's Land Army, began to view the countryside as a new site for understanding. It became a symbol of change, a motif for the war itself.

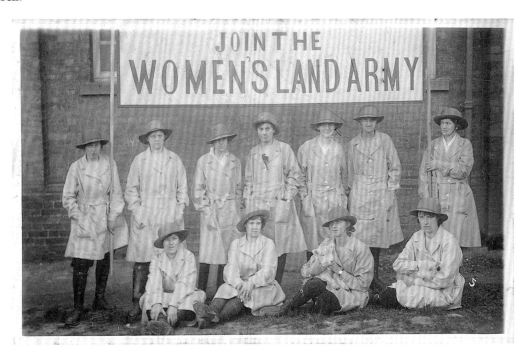

Postcard. Photographer unknown. Private collection.

Numerous women made photographic documents of the First World War, either as official photographers or as amateurs. Florence Farmborough, (1882-1978) who worked as a nurse on the Serbian front during the war, kept an intricate photographic and written record of her work and her surroundings. The studio photographer Olive Edis was commissioned to record the lives of volunteer British women war workers in France. Elsie Knocker and Marie Chisholm,

who became known as the Women of Pervyse, operated a first aid post under fire in Belgium and kept a photographic diary of their everyday lives. Although none of these photographers was specifically concerned with 'the land', all were conscious of the rural nature of their surroundings. On walks through the countryside, they would discover and photograph the corpses of soldiers, pausing to document a body lying by the side of a river, or caught in the overgrown rubble of a derelict building. For these women, engaged with the dynamics of the war, the landscape became a backdrop to action. Photography was a simple and effective way of keeping a record of events, people and places.

The First World War created its own iconography, its own mythology, and it has retained a secure place in popular memory ever since. To attempt to understand the force and cohesion of this cultural and social consciousness, we need to move away from contemporary experiences of World War One and to consider the ways in which the conflict has been remembered and redefined in the present day. One body of work which allows us to do this is Deborah Bright's *Battlefield Panoramas*, made in the early 1980s. Consciously devised as a work of art, it is constructed for a public familiar with the deconstructive signs of postmodernism.

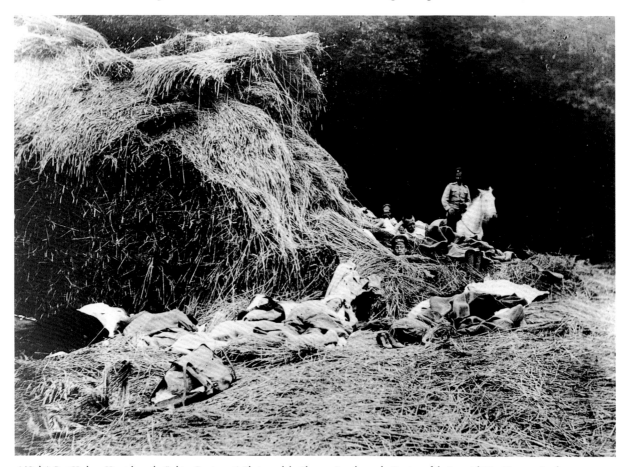

A Night's Rest Under a Hayrick on the Serbian Front. 1916. Photograph by Florence Farmborough. Courtesy of the Imperial War Museum, London.

On the Menin Road. Olive Edis. 1919. Courtesy of the National Portrait Gallery and Mrs Quita Kirk Duncan.

Bright's analysis of formalist landscape photography and the motives for its promotion are fully set out in her seminal 1985 essay 'Of Mother Nature and Marlboro Men: An Inquiry into the Cultural Meanings of Landscape Photography'.[2] Deborah Bright looks at the ways in which photographers of the landscape have been positioned, by modernist curators and by art photography publishers, in what she calls:

> a post-literate Eye, that makes photographs to see what things look like photographed, to paraphrase modernism's most-lionized master, the late Garry Winogrand. Small wonder, then, that most art-photography teachers and students are unprepared for and hostile toward any methodology that demands accountability for what is being shown in their photographs in terms of discourses other than that of a disinterested formalism.

She goes on to suggest that:

> In the American consciousness … the western landscape has become a complex construct. It is the locus of the visually spectacular, culled from the total sum of geographic possibilities and marketed for tourist consumption. For liberal conservationists, it represents the romantic dream of a pure, unsullied wilderness where communion with Nature can transpire without technological meditation, a dream that has been effectively engineered out of most modern experience …
>
> For others, the western landscape is the repository of the vestige of the Frontier, with its mythical freedom from the rules and strictures of urban social contracts – a place where

social Darwinism and free enterprise can still operate untrammelled, where tract house can sprout in the waterless desert ...

Bright's *Battlefield Panoramas*, a series of large scale photo-collages showing photographs of battle sites (some of which are from the First World War) and linking these photographs with a descriptive text, put theory into visual practice. The panoramas, and the thinking which informs them, stress that landscape, rather than being a romantic concept, as challenged by Bright in her essay, is modelled by history, by the actions of real people in real time. How we look at these landscapes in hindsight is in turn informed by a conglomeration of factual information, personal and national politics and an inherited memory. Bright's interest in European battles was prompted by her reading of John Keegan's book *The Face of Battle*:

> I visited the three battles Keegan discussed (Agincourt, Waterloo, and the Somme) and was intrigued with finding a way to photograph them that would evoke a sense of the trauma of the event that took place, even as the viewer contemplated a much transformed landscape that was often pastoral and romantic in appearance. The large scale of each panorama and the high resolution of the photographs permits viewers to see fine details in the scene which are referred to in the texts. I am also fascinated by what these sites have become to the surrounding present-day culture, whether memorial parks, working land, suburban developments, or remote wastelands. This is the reason that I note the exact month and year that I photographed these places so that future photographers might document how they have been transformed or maintained.[3]

Besides describing the date and action of the battle site, the short text suggests clues for viewers to seek out in the photographs – clues which may encourage them to reconstruct an image of what the battle scene might have looked like. Simultaneously, the conscientious recording of casualty statistics serves as a reminder of the needless waste, brutality and irrational costs of warfare.

While *Battlefield Panoramas* detailed thirteen battles, from Europe, the United States and Canada, it is *Beaumont Hamel: Battle of the Somme (France) July 1 1915. Duration: half an hour*, that is germane to the presence of landscape in our collective memory of the First World War. Bright's Somme panorama (a large 35.5 x 223.5 wall piece, comprising seven black and white photographs positioned to form a gently curving arc) is a study of a serene, sparsely peopled rural landscape in Northern France. Fields are fringed by trees, the horizon is only faintly visible. Though the outlines of the trenches are still marked, they have become pastoral hillocks, suggesting some gentle geological configuration rather than the shovelling of earth by the soldiery of the First World War. It is a peaceful, bucolic scene, a study in form and surface, the French countryside on a hot July afternoon. But the text which Bright provides, laconically written in geographer's style, belies our visual and imaginative interpretation of the photograph. She informs us (in a text piece which forms an integral part of the work), that the photograph is:

A view of heavily shelled No Man's Land from trenches of the Newfoundland Regiment (foreground) looking toward German dugouts 600 yards distant. The Newfoundland Regiment's 87th and 88th brigades were annihilated as they marched in parade formation into the machine-gun fire of the German lines. Of the regiment's 801 troops which went into action that day, only 68 stood to answer roll-call the next morning. Barbed wire supports still riddle the area … Halfway down the slope (near the sheep herd) an isolated tree marks the area where German shrapnel was particularly deadly. The Newfoundlanders called it the Danger tree and its twisted skeleton has been preserved as a memorial.

The use of such texts not as an addendum to the photographs, but as a part of the work itself, places the writing, for all its terseness, far above the level of caption. The information which it gives not only assists our reading of this particular landscape but also emphasizes the importance of deciphering the difference between visual and written language. It subverts the formalist, modernist notion, so current in the United States from the late 1960s, that a

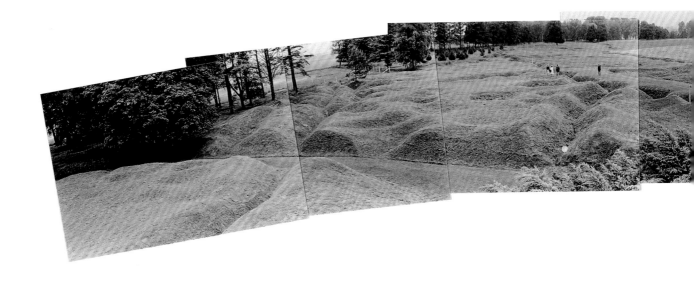

From the series Battlefield Panoramas. Deborah Bright. 1981. Silver print 35.5cm x 223cm. Courtesy of the artist.

photograph could be 'read' in the same way as a written text. Both have power, Bright suggests, but their power is effective in different ways. While the photograph has scope for ambivalent interpretation, the text is uncompromisingly factual. Between the photograph and the text lies the no man's land of our imagination, which gives us the opportunity to engage with both language and image, with the present and the past. With the addition of this text, the calm landscape of Bright's photograph is peopled with the dead and the dying, filled with the sounds of machine guns and screaming men. Beneath the soft turf of this grazing land we can imagine the blood and the bones of seven hundred and thirty-five soldiers, killed in just thirty minutes.

But the meaning of Bright's war photographs extends beyond our recognition of the historical, and she has observed that:

> When I began this series, Reagan had just been elected president and I was very disturbed by the renewal of nationalist and militaristic rhetoric that accompanied his ascendancy. These battlefield documents were certainly intended as a cumulative antimilitarist statement,

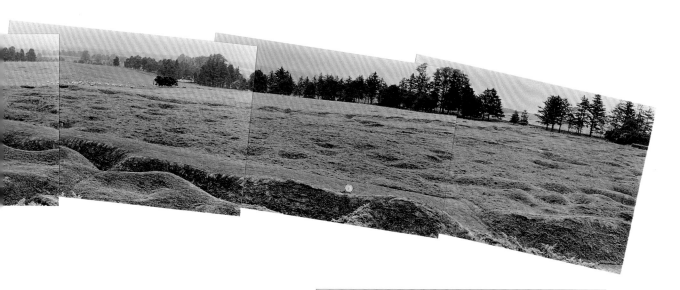

BEAUMONT HAMEL: Battle of the Somme (France)
July 1, 1915. Duration: half an hour
View of heavily shelled No Man's Land from trenches of the Newfoundland Regiment (foreground) looking toward German dugouts 600 yards distant. The Newfoundland Regiment's 87th and 88th brigades were annihilated as they marched in parade formation into the machine-gun fire of the German lines. Of the regiment's 801 troops which went into action that day, only 68 stood to answer roll-call the next morning. Barbed wire supports still riddle the area. Half-way down the slope (near the sheep herd) an isolated tree marks the area where German shrapnel was particularly deadly. The Newfoundlanders called it 'the danger tree' and its twisted skeleton has been preserved as a memorial.
Photographed July, 1981.

though I realize they are open to a number of readings, depending on the viewer's predispositions. I have been particularly interested that war veterans tended to be quite moved by them.[4]

Battlefield Panoramas challenges many notions about the meaning of photography. With its rise as an art form from the 1920s onwards, photography's position as an informational, documentary resource became less secure. The determination of American curators, historians and art dealers to promote photography as art both increased the status (and value) of the medium while at the same time making it less central to our understanding of culture and history. Postmodernist feminist artists and theorists such as Deborah Bright have, in many important ways, reinstated photography in its pre-modernist role, as information provider, chronicler and documentarist. Unlike the photojournalism which emerged during the early 1930s and became increasingly influential for the next six decades, this earlier kind of photography did not attempt to create a drama neatly encapsulated within a filmic frame. Works such as *Battlefield Panoramas* turn history on its head, and return to photography its vernacular, anti-stylistic function. Bright's work is significant too in that it has reinvested landscape photography with a political agenda and insisted that it has a use and meaning which extends beyond the merely aesthetic. As Bright comments in *Of Mother Nature and Marlboro Men*:

> Images of landscape cannot be perceived simply as an antidote to politics, as a pastoral salve to lull us back to some primordial sense of our own insignificance. Nor should they be regarded simply as the loci of our modernist pleasure in arrangements of material objects in ironic constellations – found 'happenings' for the lens whose references to the worlds beyond the frame rivet all attention to the sensibility of the artist.

A world away from the conscious redefining of photography's role which Bright promulgates, is Rose E.B. Coombs's *Before Endeavours Fade: A Guide To The Battlefields of the First World War*,[5] published in 1976 by Battle of Britain Prints International. This first edition has now been reprinted five times. The book is a detailed guide to battle sites, complete with map references, advice about accommodation, eating places and, most significantly, a photographic documentation of memorials, vantage points and landmarks. It also contains a number of montaged photo-maps. *Before Endeavours Fade* is a fascinating document, indicative of our continuing compulsion to revisit these sites of conflict, to gaze on cemeteries and monuments, to attempt to position a long-distant past within the scope of a contemporary imagination. It is geared towards a specialized niche of the leisure industry, made up in part by bereaved families and veterans (both of whose numbers must grow smaller each year) and increasingly, by military hobbyists interested in retracing the actions of the armies of the First World War. To read its text and to study its photographs is a disturbing experience: one becomes a sightseer gazing at pictures whose ostensible message is quite explicit – to provide identification to the visitor, whatever his or her motivations may be for coming. There is no attempt in these images to stir an imaginative response – for the most part they are mundane, sometimes blurry

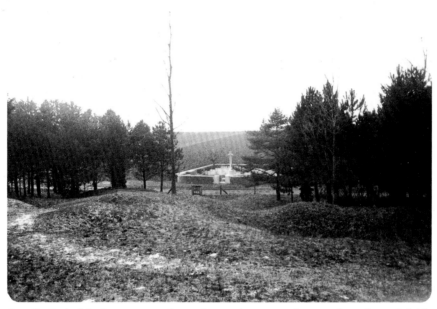

From *The Battle of the Somme, a section from* Before Endeavours Fade: A Guide to the Battlefields of the First World War *by Rose E.B. Coombs 1976/1990.*
'From the shelter of the Sheffield Memorial the view is down to Railway Hollow Cemetery, the Accrington Pals' Valhalla.'

snapshots, photographs taken for a very particular reason, and not for the sake of art. Critics and curators of the kind so trenchantly critiqued by Deborah Bright would have ignored these photographs, believing them to be lacking a cogent aesthetic dynamic. But it is in their very plainness, in their bleak documentary style that we find the explicitness of their meaning.

Like Deborah Bright, Rose Coombs visited Beaumont Hamel, site of the Battle of the Somme. Like Deborah Bright, she too encountered the battlefield in mid-summer, and felt the full force of this eerie, still battle-scarred bucolic landscape:

> Even on a fine, sunny summer's day, the park seems to have a definitely foreboding atmosphere and, after a thunderstorm, I have smelt the awful stench of battle in the still, deep, trenches. Nowhere else in my travels on the Western Front has the horror of war come nearer to me than here on one very hot evening following a clear day. It was late July and, as I wandered across the shell-torn slopes towards the German lines, the sound of thunder was heard in the distance, getting gradually nearer as might an artillery barrage. The light grew dim and black clouds gathered overhead. Lightning streaked across the sky – a veritable reincarnation of what a barrage must have been like.[6]

Coombs's text reads into this modern scene an evocation of past events, just as Bright uses her informational writing to transpose the present to the past. That the two pieces of work are intended for vastly differing audiences is an added fascination. Both are moves made by

From the series *Seven Miles of Mud*. 1992. *Elizabeth Williams*. Number three of five in *Sequence four*.
C type print. 47 cm x 70 cm. Courtesy of the artist and Montage Gallery, Derby.

women, distanced from the war by decades, to imagine this very male, militaristic past. Like Vera Brittain, they are trying to make sense, through a study of landscape, of an historical fact almost impossible to comprehend.

Rose Coombs goes to particular pains to describe and locate memorials, testaments to collective memory, guilt and grief. From small gravestones which act only as symbols (the bodies of the men they commemorate 'lost in later battles') to the Caribou Memorial which marks the massacre of the Newfoundland Regiment, they are a corporate expression of bereavement; fantasy cemeteries where the bodies have been lost. Photographs like these, and the memorials they record, are markers on a map of memory, blurred witnesses to the ways in which we remember wars. Their strength lies partly in their imperfection, in their likeness to the photographs which we too might take of these eerie places, part theme park, part graveyard. *Before Endeavours Fade* poses important questions about the way we decipher and decode the landscape of war. Like *Battlefield Panoramas*, it gives information which belies appearances and makes complex the meaning of the most simple landscape photograph of a peaceful woodland, a simple country church or a quiet river backwater. In one aerial view of Beaumont Hamel, the photograph is carefully annotated with signs which mark the sites of battle and the memorials which now punctuate the landscape.

There is no political agenda in this singular guidebook, no discussion of the rationale or motives for these battles, only an acknowledgement that they were fought, and a statistical summary of those who died, the number of troops involved, the size of the bomb craters, the depth of the trenches, the precise position of field hospitals, headquarters and the like. And it is in this very understated numbering and counting, dating and measuring, that the force of this book lies. Everywhere there are cemeteries, small ones which nestle near woods and farmsteads, large ones which dominate the surrounding countryside. It is a landscape of the dead, of countless corpses, a site of remembrance and pilgrimage. And it is too a manipulated countryscape, where the crosses and obelisks of memorials stand uneasily among the more fluted and flexible forms of nature. These memorials are uneasy additions to this countryside. They have a municipal quality, made by masons rather than artists, their forms couched in the stiff terminology of the monumentalist's craft. Like the follies of a Victorian squirearchy, they have presence without real function save to act as *aides memoires*.

Memories of the First World War, whether contemporary or of our own time, are remembrances of private grief become public property. These landscapes, formed by the long-dead and seen through the guidebook compiled by Rose Coombs, or the artworks constructed by Deborah Bright, the autobiographies of Vera Brittain and Madame Yevonde or the photographic diaries of Florence Farmborough and Olive Edis, are attempts, made by these very different women, to describe and comprehend the logistics and meaning of war.

Writing about the Battle at Beaumont Hamel, Rose Coombs advises her readers:

As the visitor crosses the battle area, it is noticeable that some of the shell holes contain much battle debris; rusting helmets, broken shells, barbed wire and the iron pickets on

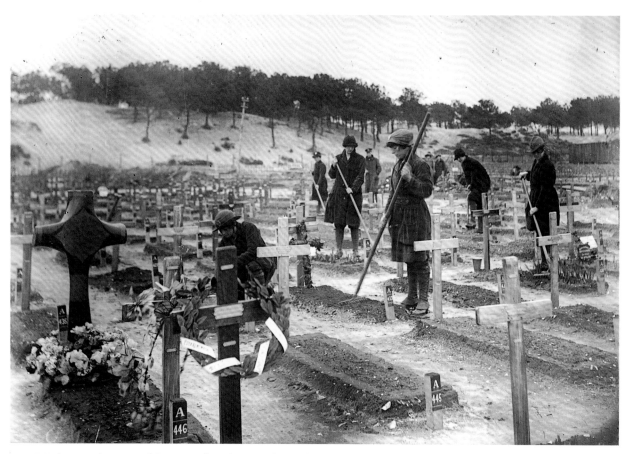

WAAC Gardeners Tending Graves of the War Dead. Etaples, 1919. Photograph by Olive Edis. Courtesy of the Imperial War Museum, London.

which the wire was hung. These collections are not there for the taking and it is requested that they should be looked at and not pilfered. Even today many shells and often hand-grenades can be found emerging from the greensward. Should the visitor find a dangerous item, leave it alone and advise the Superintendent or one of the gardeners working in the park.[7]

Coombs's language is understated, meticulous and proper. Her phrasing is that of the Women's Institute, but her terminology is that of violent death, of mass anonymity, of a landscape irredeemably polluted and scarred.

Photography is a deceptive and sometimes misleading medium. It is confusing and perplexing that 'mundane' work like that in *Before Endeavours Fade* can perhaps be more stirring than the iconic photographs of Richard Misrach or Jon Pfhal, more moving than the sensuous landscapes of Edward Weston or Ansel Adams, more starkly 'real' than the determinedly 'everyday' photographs of Robert Frank or Joel Meyorvitz, and more horrifying than the graphic and dynamic war reportage of Robert Capa. Rose Coombs's photographs are to do with their subjects rather than the ways in which those subjects could or should be seen. Neither

innocent nor naive, they are photographs made for a purpose, a pure use of the medium to record a most salient fact. There is no beauty in these photographs, nor in the text which accompanies them, and no romantic ugliness either; Rose Coombs emerges as a less than suitable candidate for membership of what Deborah Bright calls: 'a male preserve in art photography. The image of the lone, male photographer-hero, like its prototypes, the explorer and hunter, venturing forth into the wilds to capture the virgin beauty of Nature, is an enduring one.'[8]

Rose Coombs's *Before Endeavours Fade* is such a pragmatic exercise that we can easily appropriate it for our own purposes. We could almost call it 'found'. The photographs, and the texts which accompany them, become a site for our own fictions, our own memories. They can tell a number of very different stories.

The concept of the landscape of First World War battlefields has also been used as a site of fiction by Elizabeth Williams, an English artist working with photography who, over the last decade, has been producing work which deals with landscape as a site for a particular politic. In her sequential artwork *Seven Miles of Mud* (1992), she 'combines the discourse of historical images from the First World War with evidence of environmental aggression in terms of inferred metallic contamination, the invasion of the artefact into a 'natural' site, and the increasing fracture of surface'.[9]

Elizabeth Williams, like Deborah Bright in *Battlefield Panoramas*, has propelled past events into a contemporary discourse, has challenged the notion of 'history' as a chronology lodged firmly in the past. While the title of her work originated from 'the Battle of Passchendale in the First World War, in which 471,423 lives were lost in order to move The Front over seven miles of mud',[10] she has sited the photo-series in a contemporary context, making allusions to, at one point 'conditions in The Gulf War and the First World War and the implications of the effect on the environment'.[11]

The landscape of the battlefields of the First World War is one in which the detritus of death is constantly present. Williams has noted how the colour of the soil is changed when affected by gas fumes, and cites paintings by World War One artists Paul Nash and E.R.W. Nevison as references for her own artworks. She has looked closely at objects which litter the earth, and although the landscapes she photographs are in Southern England rather than France or Belgium, they are intercised with marks and signs which can be relocated within our knowledge of history. The grey, glutinous masses of mud which she photographs assume a massive presence, reminding us of the thousands of men who died not just as a result of wounds and injuries, but also by literally drowning in a sea of slime.

In these delicate details from a wintery English landscape, one can sense a tragedy of the utmost gravity. *Seven Miles of Mud* is an unrelentingly beautiful and painful piece of work, which Williams herself has described as occupying that no-man's land between fact and fiction which, in our memories, we all inhabit.

Progressing from the seemingly 'naive' photographs made by women working at the Front

in the First World War, then encountering Deborah Bright's carefully wrought *Battlefield Panoramas*, and Elizabeth Williams' *Seven Miles of Mud*, informed as they both are by a sophisticated theoretical and aesthetic perspective, only to find this neat cycle partially confounded by the populist product of *Before Endeavours Fade*, is a provoking exercise. It highlights the problematic nature of photography, its status both as fiction and as fact, as maker of chronicles whose sense and meaning changes as audiences alter and opinions shift.

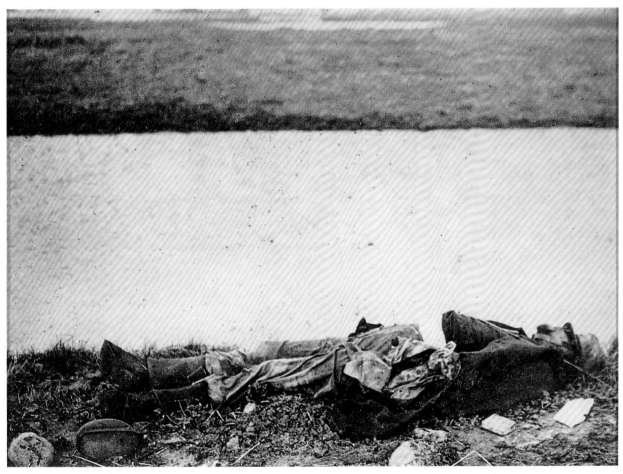

Dead soldier, photographed by Elsie Knocker and Marie Chisholm, first aid workers in Belgium during WWI. c. 1917.

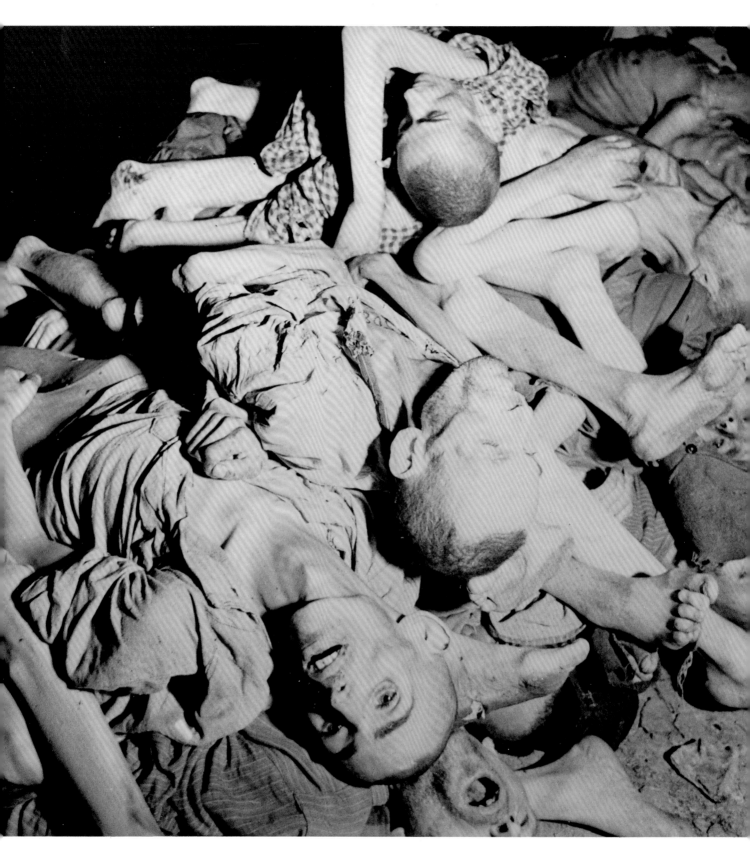

Buchenwald Concentration Camp, Germany. Lee Miller. 1945. Courtesy of the Lee Miller Archive.

SHADOWS ON THE BODY
Photography and the Holocaust

The Holocaust of the Second World War has produced massive and painful photographic documentation, part of it highly familiar, some known only to historians and specialist curators. Much else lies forgotten, uncatalogued and inaccessible. Many chronicles of the Holocaust lie in the megalithic state archives of the former communist bloc of Eastern Europe, while elsewhere, photographs in the private collections of families, individuals and institutions remain hidden from our gaze. Time, circumstance and shame have undoubtedly destroyed many vital pieces of photographic evidence which would allow historians to piece together the fragmented history of the genocide of World War Two. This tendentious subject is encircled by taboos. When we look at photographs of the Holocaust, and most particularly of the death camps, we consider their content rather than the aims and motivations of the photographers who made them. Our pity for the people who appear in these photographs places a restriction on the ways in which we can consider them. When we come across images of the camps, the iconography of wasted bodies and mangled corpses is so familiar that we anticipate what we will see.

The Holocaust and its iconography has a public whose agendas are diverse. Photographs have an inalienable status as evidence, and after the end of the Second World War, photographs made of the death camps and the ghettos were used both as a way of informing the public of the crimes of the German SS and to prosecute war criminals. In more recent years, Holocaust iconography has been used, sometimes by survivors of the concentration camps, but more particularly by a younger generation of European Jews, to begin a search for the meaning of the past, a quest for an identity. Searching among the faces of the disappeared, they look for links to an obscured history. Whatever our agendas may be, Holocaust imagery has become part of our visual and emotional vocabulary. Fifty years after the liberation of Europe, its resonance is still felt, and its images are imprinted on our consciousness.

Holocaust imagery is continuously adapted and remodelled. Recently, the high camp French photo artists Pierre et Gilles used a photograph of a young man in the striped uniform of a

concentration camp prisoner, surrounded by lighted candles and seen through barbed wire, in their piece *The Pink Triangle*. Beautifully framed and hung in the luscious surroundings of an Austrian state art gallery,[1] its ironies are multiple, and its glamour unmistakeable. *The Pink Triangle* emphasizes that the Holocaust, as well as being part of Jewish history, is also part of the collective memory of gay men.

In his installation series *Schrift an der Wand* (1991), the American artist Shimon Attie has recreated, by use of projections, the lives and homes of the Jewish citizens of Berlin in the late 1920s and early 1930s. On decayed doorways and dark streets, he has pictured men, women and children going about their everyday lives, wheeling prams, entering cafes, peering from windows. Set against the backdrop of modern Germany, these artworks make real the ghosts of the victims of a tyrannical past. A blank warehouse facade becomes, for a moment, the site of a stall selling caged birds, a news-stand appears on a concrete wall, the signwriting of a Jewish record store is superimposed on a 1990s shop front.

The poverty and oppression of the German Jewish community is obvious in these projected photographs; a man begs on the street, children cluster near the gutter, their faces thin and their clothes tattered, a soldier guards a door of a Jewish home while an anxious crowd gathers outside. Attie's own response to the Holocaust, as an artist and as a young post-war Jew, is literal and direct. It juxtaposes the past with the present and presents us with the flickering evidence of the disappeared.

How we see the Holocaust, which photographs we resort to to represent our witness of these times, depends on who we are, and what we need to know, which facts we wish to verify, and which to obscure. The division between Second World War and Holocaust photography can become blurred and perplexing. By the time the war began, photographers had become accustomed to photographing battle and conflict, and an aesthetic framework had been established. When these war photographers encountered the Holocaust, their perceptions of what photography could or should do were set awry.

In the film *Schindler's List* (1993) director Steven Spielberg made extensive use of Holocaust photography archives in order to make scenes in the film true to original events in the Krakow ghetto and in the Auschwitz concentration camp.[2] In such a memorialisation of the Holocaust, photographic documentation has formed a major source of information.

Issues emerging from the ways in which Holocaust photography are used have become the centre of important debate. In 1993, Philip Gourevitch, a New York journalist writing for a Jewish newspaper, went to the recently opened Holocaust Memorial Museum in Washington, DC. A child of Jewish refugees from Nazism, Gourevitch visited the museum in the consciousness that 'my life belonged not only to me but to the course of history'.[3] During his tour of the museum, Gourevitch became confused, angry, and assaulted by the photography and film on display:

Before visitors even reach the first exhibit on the rise of Nazism, they have been dealt a visceral, emotional wallop with the graphic evidence of the end result: Jewish corpses. The

effect is, at the least, shocking. A wincing, uncomfortable silence hangs over the crowded gallery, punctuated by clucked tongues and staccato gasps of outrage – sounds that become less frequent as the museum tour continues and visitors recoup their defences or become accustomed to images of horror. [4]

In his piece, Gourevitch attempts to understand the museology of the Holocaust. After watching the films which show the activities of the *Einsatzgruppen* (mobile killing squads) he wrote in his notebook:

Naked women led to execution. People are being shot. Into the ditch, shot, spasms, collapse, dirt thrown in over. Crowds of naked people. Naked people standing about to be killed, naked people lying down dead ... Mass graves of thousands. Naked. Naked corpses. Naked corpses. Street beatings. The gun, the smoke, a figure crumbles. Naked corpses. Naked woman dragged to death. Shooting, screaming. Blackout. The film begins again. [5]

When he reflected on what he had seen, he wrote:

It was not exactly depression or fear or revulsion that overcame me as I stood before this exhibit, though I experienced all these reactions at one time or another in the museum. Nor was it that I had seen it all before. The problem was simply that I could not make out the value in going through this. The Holocaust happened – it should be remembered and it should be made repellent. But I felt the way I did when I was a child waking from my nightmare: I know that this is hell and I know that it is true, but the ethical dilemmas and the political choices that I face in my life are not those of the Holocaust; nor are the crises of America those shown in this museum. [6]

Gourevitch's response to this public display of Holocaust imagery is a provoking one. The emergence of so many photographs after the end of World War Two has made this particular tragedy uniquely accessible. Gourevitch's suggestion is that its use, in this context, is also propagandistic – by exemplifying this persecution and genocide in 1940s Europe, America may well be partially liberated from the guilt brought about by its own political and military activities in the post-war years.

Some of the photographs which Gourevitch saw during his visit to the museum would have been produced by Allied photojournalists, arriving at concentration camps with the liberating armies. These men and women have provided us with important witness statements. Margaret Bourke-White and Lee Miller were two of the first photojournalists to document these phantasmagorical sights. Their photographs, frequently published, have become symbolic of that period in history. As such, they form an important part of the documentation of the Holocaust.

Lee Miller (1907-1977) arrived at Buchenwald in April, 1945. As a correspondent with the US Army she recorded, in words and pictures, the terrible sights she witnessed. Memorable photographs show emaciated corpses, every bone visible, piled on top of each other, eyes

staring, mouths open. These photographs were vital as evidence of genocide, particularly when they reached Britain and the United States where a not inconsiderable number of people would have preferred not to have known about the information they contained. Lee Miller photographed German citizens from nearby towns and villages being taken around Buchenwald by US troops to see the bodies, the gallows and the living conditions of internees. Her remarkable series of portraits of SS prison guards beaten and bruised by former inmates is frequently republished. She made photographs of SS suicides (a theme she was to return to throughout her travels through Germany), and constructed a portrait of a world in which moral values had been put aside.

Lee Miller was no hardened war correspondent when she went to Buchenwald. Before the war she had worked as an avant-gardist in Paris, under the tutelage of Man Ray. In wartime England she had photographed utility fashions for *Vogue* magazine, documented the WRENS [7] and made a surrealistic series of photographs of bomb-damaged London, eventually published in the 1941 book *Grim Glory*.[8]

While this earlier work had demonstrated the cool sensibilities of the 1930s avant-garde, her German photographs of the mid-1940s displayed a fierce and adamant anger. Of the Germans she wrote, in a dispatch to *Vogue*:

I begrudge every blade of grass, every cherry for the thrifty preserve-cupboard, each furrow and each intact roof.

My fine Baedecker tour of Germany includes many such places as Buchenwald which were not mentioned in my 1913 edition, and if there is a later one, I doubt if they were mentioned there either, because no one in Germany has ever heard of a concentration camp and I guess they didn't want any tourist business either. Visitors took one-way tickets only, in any case, and if they lived long enough they had plenty of time to learn the places of interest, both historic and modern, by personal and practical experimentation.

Now, in spite of the fact that the local Gestapo Rotary Club did no advertising, a constant stream of tourists arrives in this camp to see the horrors. They are not in the least like the rubbernecks of the Blitz, nor are they idle curiosity seekers. They are not a funeral procession, nor are they holiday-makers together. General Patton thought that since the inhabitants of Weimar had never heard of concentration camp brutalities, a couple of thousand of them, all sexes and ages, had better come calling at the camp they knew nothing of, but which housed and buried so many thousands of people within easy walking distance of home for such hardy rucksack bearers.[9]

Another major American photoreporter who entered the concentration camps in the early days of the Liberation was *Life's* distinguished photojournalist Margaret Bourke-White (1904-71). Unlike Lee Miller, Bourke-White was already a veteran reporter. By 1944, she had published two books of war photography, *Shooting the Russian War* (1942) and *They Called It Purple Heart Valley: A Chronicle of the War in Italy* (1944), as well as producing many war photo stories for *Life*.

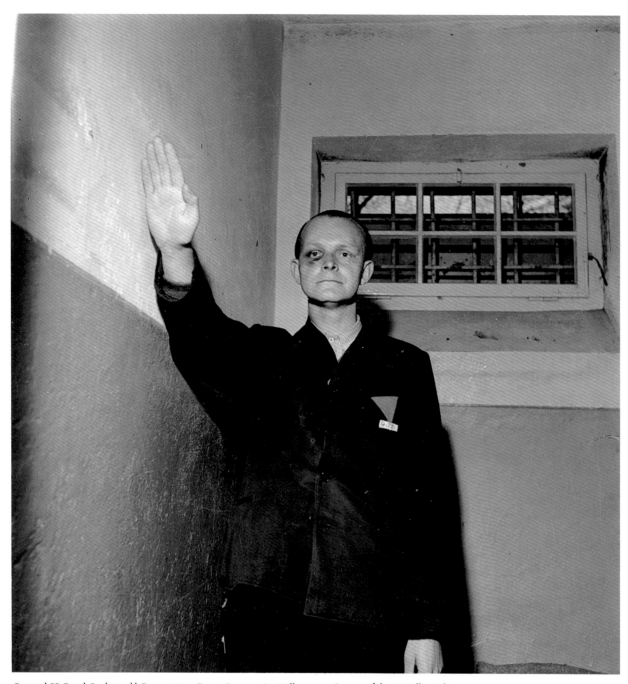

Captured SS Guard, Buchenwald Concentration Camp, Germany. Lee Miller. 1945. Courtesy of the Lee Miller Archive.

Margaret Bourke-White was of Polish-Jewish origin, on her father's side, although throughout her childhood, her Jewishness was carefully concealed. Her biographer, Vicki Goldberg, has described her mother, Minnie, as being 'calmly anti-semitic'. [10] Goldberg has noted how, when writing about Buchenwald in 1945, 'Margaret, maintaining her secret, did not mention Jews ... but made clear her outrage'. [11] Like Lee Miller, Bourke-White saw her photographs of Buchenwald, and other smaller, but no less horrific camps, as important witness statements:

> Even though I did not realize how soon people would disbelieve or forget, I had a deep conviction that an atrocity like this demanded to be recorded. So I forced myself to map the place with negatives. [12]

Margaret Bourke-White's photographs were produced, like Lee Miller's, with a particular end in view. They acted both as news and as war-crime evidence; Bourke-White's photographs of the camps were later used during the Nuremberg trials. Like Miller's, Bourke-White's images, and her descriptions of the scenes at the camps, were infused with anger. She wrote some years later:

> People often ask me how it is possible to photograph such atrocities. I have to work with a veil over my mind. In photographing the murder camps, the protective veil was so tightly drawn that I hardly knew what I had taken until I saw prints of my own photographs. It was as though I was seeing these horrors for the first time. I believe that many correspondents worked in the same self-imposed stupor. One has to, or it is impossible to stand it. [13]

After the end of the war, personal stories were frequently rewritten. Photographic curator and collector Joachim Schmidt has noticed, in the course of his researches into German family albums of the 1930s and '40s, that photographs have sometimes been removed from their pages. Looking at these anonymous documents, one is bound to conjecture about these missing pictures. Were they removed to be destroyed or hidden in some secret place, or did they graduate to some more public situation, framed on a mantlepiece or hung on a sitting-room wall? Did their presence reveal some evidence of misdeed, the wearing of a swastika, the membership of some now discredited group? Their removal may have sought to redefine and remake a personal history. Photographs in their absence can have a stronger presence than those we can actually see. The scratches on the surface of an album page, the mark of a photo corner still visible – all are clues to a riddle which is seldom solved. Photography's status as evidence makes it a problematic medium – we believe what we see, knowing that seeing is not always believing. Those who were implicated in the rise of the Third Reich have their own reasons for concealing the visual evidence which confirms their complicity to themselves, to their families and to the outside world.

For those who were persecuted in Europe during the war, the absent photograph has a different meaning. For many who survived the Holocaust, lost family photographs are remembered in precise detail. They become symbolic of heritage and of loss, part of both a

collective and a familial memory. For subsequent generations they have become partial clues to the meanings of a catastrophe, which, despite the frequent retellings of its history, must always remain inexplicable.

In the mid 1980s, Frau Dr Jolana Roth, a Czechoslovakian survivor of Auschwitz, was interviewed by the historian Claudia Koonz, in the course of research for her book *Mothers in the Fatherland*.[14] While imprisoned at Auschwitz, Frau Dr Roth was sent to 'Canada', the notorious warehouse and sorting shed where the possessions of those who had been sent to the gas chambers were sorted, recycled or destroyed. Family photographs, which deportees invariably brought with them to the camps, were always burned. Processing clothes in 'Canada', Frau Roth came upon:

> … a scrap of my own high school portrait burned at the edge. My father always carried it with him. He was so proud. He would never have let it go. I tried to keep it, but we couldn't keep anything. It's gone now, with the rest.[15]

The fragmentation and destruction of school portraits like these was a fundamental part in the loss of identity experienced by those imprisoned in the camps. Such a photograph, kept by a father of his daughter as a loving *aide memoir*, becomes symbolic of a world of domestic and family comfort irretrievably destroyed. Torn and violated, the privacy and sanctity of this family portrait has disappeared, and the evidence of passing years obliterated.

Photographs were sometimes able to be saved by those forced to carry out the macabre work of processing the possessions of the dead in the camps. The story of one survivor of Sobibor, Yaakow Biskowitz, is told in this way:

> Eighty Jews were forced to work in Camp 3, burning the bodies which had been gassed. They also had to sort out the clothing of those who had been killed. Damaged clothing, and all personal documents were burned. One day a young man who had known Biskowitz in Hrubieszow brought him some photographs. While burning the personal belongings of those who had been gassed, he had recognized the photographs of Biskowitz's family. 'He brought these pictures out of the fire', Biskowitz recalled. His family had been killed. It was June 3.[16]

Olga Lengyel, another Holocaust survivor, also saw the family photographs which she had brought with her to Auschwitz as an almost unbearable reminder of a past life, and as a witness to a present shame. Subjected to the humiliation of the induction process to Auschwitz, Frau Lengyel remembered:

> A few of my neighbours tried desperately to keep their papers – some their prayer books, or photographs. But the guards were eagle-eyed. They slashed out with the iron-tipped clubs, or pulled hair so hard that the unfortunate women shrieked and collapsed upon the ground. 'You won't need identification papers or photographs any more!' cried the mockers. I lined up in my row, completely naked, my shame engulfed in terror. At my feet lay my clothes,

and, on the top, the pictures of my family. I looked once more at the faces of my loved ones. My parents, my husband and my children seemed to be smiling at me ... I stooped and slipped these dear images into my crumpled jacket on the ground. My family should not see my horrible degradation.[7]

'Consider', wrote Primo Levi as he remembered the first days of his imprisonment at Monowitz:

what value, what meaning is enclosed in even the smallest of our daily habits, in the hundred possessions which even the poorest beggar owns: a handkerchief, an old letter, the photo of a cherished person. These things are part of us, almost like limbs of our body; nor is it conceivable that we can be deprived of them in our world, for we immediately find others to substitute the old ones, other objects which are ours in their personification and evocation of our memories.[8]

Levi's recognition of family photographs as the most basic and common of possessions underlines the importance of the destruction of these profound documents of relationship. The family photograph is like a mirror, giving a reflection of how we appeared at one moment in time, indicates our choice of clothes and our surroundings, notes a smile or a grimace, and maps relationships. These images become votive objects, carried next to the heart, borne like the charms of the superstitious to guard against the malice of an unpredictable world. They are symbols of place and change; they remind us of the past, and reconnect us with the familiar.

As Primo Levi points out, prisoners in the concentration camps were deprived of their identities, and identity rests very much in the ways that we see ourselves in regard to others. Deprived of the benchmarks, not only of belonging to a known structure, but of recognizing others in relation to one's own social group, or generation, or family, can render the individual almost invisible.

Memoirs of Holocaust survivors are often remarkably vivid, and one must suppose that this clarity emerges not only because of the horrors of the events which overtook them, but also because the familiar means of documentation – diaries and cameras – were no longer available to them. Instead, the mind took photographs and stored a set of images which later served as witness testimonies. Many survivors of the Holocaust are able, more than fifty years after the end of the war, to describe their experiences in great detail, their lucidity being able to take us back to the precise events of those terrible years. Trauma can imprint events deeply on the memory, producing an image as detailed as a photographic print.

For many survivors, memories of pre-Holocaust family photography are both acutely painful and deeply cherished. Photographs, taken in happy days, serve as a poignant counterpoint to the memories of Nazi persecutions which began in the early 1930s. One such survivor, interviewed recently for the National Life Story Collection at the National Sound Archive remembered:

I've got a photo of my mother, father, grandfather the Sunday before I came to England; it's a historic photo. And we look so innocent; we're sitting in a cafe, the trees are in bloom, it's mid-summer, my mother's got a 1930s dress on and a smart hat. You wouldn't think anybody had a care in the world, and I was about to get on a train in order to have my life saved. My grandfather was shot in the street a few months later and my parents went to concentration camps and got killed. And to look at us you wouldn't have believed anything was happening, it's just quite ridiculous.[19]

In histories of the Holocaust, photographs are used in many different ways. Some illustrate the horrors of beatings, humiliations and executions or the privations of the ghettos. Others, saved somehow from the immolation, have a very different appearance, but their importance is as profound. They show families at home and on holiday, children at school or on outings in the countryside. They are illustrations of a time in which normality and continuity was suddenly and catastrophically interrupted. In the 1993 British Library publication *Voices of the Holocaust*,[20] the authors have chosen as an illustration a photograph of a 1915 outing of Jewish schoolchildren to Gnesen in Poland. Everything which makes up a group photograph is in place: there are the shy children who stand alone, unsure of the face they should make to the camera, the extroverts who smile directly into the lens, the lucky best friends, secure in their

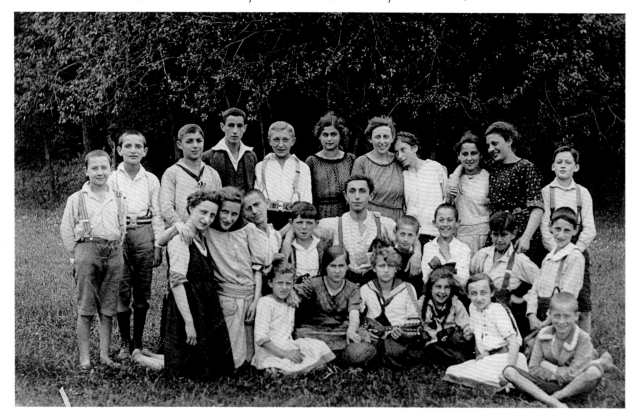

An outing of Jewish children to Gnesen in Poland, circa 1915/16. Photographer unknown. Courtesy of the Manchester Jewish Museum.

pairing, arms around each other, lost in the closeness of childhood bonding. There are the well-dressed children and the pretty ones, happy in their own attractiveness or the smoothness of their clothes, the mavericks surrounded by the aura of their independence, and the adolescents, half-scornful of this world of children, half-longing to be infants again. Unless they were able to emigrate, it is probable that all but a very few of these young people would have perished as they grew up and reached adulthood during the Nazi years. Unlike the survivors, who have lived on to recount their stories, these children are mute. On their behalf, photography delivers its eloquent and beguilingly simple message.

Standing in direct contrast to these simple family photographs are the images made by perpetrators of the Holocaust and by those who simply looked on. These photographs pose complex questions about the ways in which we look at historic images. The many published histories of the Holocaust usually include a section of photographs which deal with the persecution of Jewish communities from the early 1930s, in the ghettos, and in the concentration camps. Historians include these photographs in their books as illustrations, acknowledging the archive or institution which owns them, but rarely giving a thought to the photographer or to the motivations which lay behind the picture taking.

Combing through Holocaust histories, one is able to find some reference, if only in passing, to the circumstances surrounding the making of these photographs. After a mass killing of Jewish men, women and children in Nazi occupied Russia in 1941, historian Martin Gilbert recounts how:

> Two of Lieutenant Bingel's men suffered 'a complete nervous breakdown' as a result of what they had witnessed. Two others, arrested for having taken 'snapshots of the action', were sentenced to a year's imprisonment, and served their term in a military prison in Germany.[21]

Though many of the photographs taken in Eastern Europe in the early 1940s were taken by amateurs, some had a more official function. Testifying in 1958, a German military photographer who recorded the murder of Jews in the centre of the Lithuanian town of Kovno remembered how he was apprehended by an SS officer:

> [he] came up to me and tried to confiscate my camera. I was able to refuse since in the first place the camera was not mine but had been allocated to me for my work, and second I had a special pass from 16th Army High Command, which gave me authorization to take photographs everywhere. I explained to the officer that he could only obtain the camera if he went through Generalfeldmarschall Busch, whereupon I was able to go on my way unhindered.'[22]

Another soldier taking photographs of the Kovno massacre testified:

> As I was an amateur photographer I took two photographs of this unbelievable incident from where I was standing on top of my vehicle. As I had finished the film I took it out of the camera in order to put in a new one. Just then I was confronted by an officer of the

Wehrmacht ... who told me that it was not permitted to take photographs of such events. I had to give him my particulars and the name of my unit and he confiscated the camera. I was only able to save the pictures because I had already taken the film out of the camera.[23]

It is evident, that in this early and chaotic stage of the Holocaust, many German soldiers photographed mass killings. Nazi attitudes to photography of its own atrocities were ambivalent. Writing in the introduction to *Those Were The Days*, a compilation of photographic, written and transcribed records made by the 'perpetrators and bystanders' of the Holocaust, Lord Dacre observed that:

> The particular significance of this book is that in it the facts are recorded not by Jewish survivors but by German witnesses: men who, by chance, or in the course of duty, or out of curiosity, observed the events as they occurred and made a record, sometimes a photographic record, of them. Such records were strictly forbidden at the time – the SS did not want any evidence of its work to survive.[24]

One SS officer was even court-martialled for taking 'tasteless and shameless photographs' of Jewish prisoners and mass executions; then giving them to a local chemist to be processed and showing them to family and friends. Writing in the Preface to this remarkable and deeply shocking book, the authors note:

> The book contains a large number of photographs which speak for themselves. These pictures do not portray fanatics foaming at the mouth as they commit murder, nor do they show beasts who arouse our disgust, but perpetrators (spurred on by spectators) performing their 'work' and who afterwards, exhausted but satisfied, enjoyed a few beers in their free time. These pictures show people whose appearance does not betray that they were active participants in the mechanics of murder, or ready and willing operators.[25]

These are very different documents from those which emerged from the cameras of western photojournalists during the liberation of the concentration camps. The photographs made by reporters such as Margaret Bourke-White, Lee Miller and *Life* photographer George Rodger are full of the horror, not only of the scenes themselves, but of the photographers who viewed them. Those earlier pictures made by German soldiers and by spectators, of people torn from their homes, lining up naked to be shot, were taken not by horrified people, but by interested and curious ones. Taken carefully too, with an eye for detail and composition, and preserved throughout the war. Placed within the iconography of the Holocaust, their authorship has become unacknowledged; in the many publications in which they have been reproduced they take their place alongside photojournalistic reports from the death camps and family photographs. Holocaust photography has become appropriated as illustration and evidence, perhaps without due consideration of the importance either of authorship or motivation. This issue, important as it is, remains undebated.

The taboos and the fear which surrounded Holocaust imagery were so profound that not

" WHY IS THE WORLD SILENT "
(Chaim Kaplan)

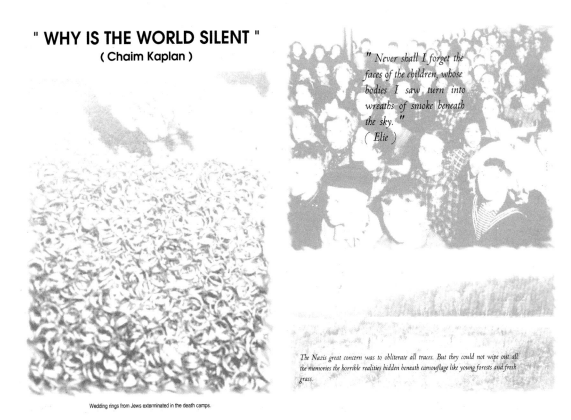

" *Never shall I forget the faces of the children, whose bodies I saw turn into wreaths of smoke beneath the sky.* "
(*Elie*)

The Nazis great concern was to obliterate all traces. But they could not wipe out all the memories the horrible realities hidden beneath camouflage like young forests and fresh grass.

Wedding rings from Jews exterminated in the death camps.

Detail from the installation Shoah. Laser printed on linen. Rachel Lichtenstein. 1993.
Courtesy of the artist and the West London Synagogue.

until the 1980s did artists using photography begin to look carefully at the photographs which the Holocaust had produced. The most prominent of these is the French artist Christian Boltanski, who has made artworks which, while never referring directly to the Holocaust, acknowledge the power of absence, of photography's ability to describe negativity and loss, its way of dealing with the dead. As the first major European to use found photography to obliquely examine the issues which emerge from the Holocaust, Boltanski's influence on both his contemporaries and on a generation of younger artists was profound.

Boltanski has read the message conveyed by the photographs of the lost children of Europe with great accuracy. Throughout the 1980s, he constructed a number of installation pieces which used as their centrepieces school photographs of children in France and Austria during the 1930s. Boltanski's *Monuments: les Enfants de Dijon* (1985) is a set of full-face archive portraits of schoolchildren. He arranges these photographs in dimly-lit halls with only bare light bulbs to illuminate the image. Some are hung singly, while others are positioned in groups, and emerge as altar-pieces. The effect of these faces, each in its own pool of light, connected only by the criss-crossing of electrical wires is one of the most deeply moving to be found in western contemporary art. Lonely, yet connected in the great, darkened places in which Boltanski

installs his work, these portraits make one feel present at some crucial act of both piety and anger. Fragments of a time lost, they are photographs of the dead. There is no documentation to accompany these pictures, no names or times, for these children represent not only themselves, but also a lost generation.

In the last decade, contemporary artists have begun increasingly to produce works which examine the nature of the Holocaust. In 1993, Rachel Lichtenstein (b.1970), a young artist living and working in the East End of London, was commissioned to make a work to be hung as part of a permanent display in a London synagogue. *Shoah* consists of photographs and texts, chronicling the history of the Holocaust, printed on to fragments of cloth, sewn together and hung on a number of screens.

The strength of *Shoah* comes not just from the events it depicts – photographs of children in the ghettos, scenes from Kristallnacht, a portrait of Anne Frank – but also in the way it invokes a collective memory, shrouded by time but resonant with pathos and angst. The photographs on the fabric are faint and grey, like ghosts they live on even though the lives of their subjects have been extinguished. Patches of linen, sewn together to form a whole, suggest a fragmentation of history and heritage which has been carefully, if only partially, reconstructed. The stitching together of the patches implies a painstaking effort, perhaps in homage to the fruitless and cruelly exacted toil of those who died, both in the ghettos and in the camps. It is a work, one feels, which has been pieced together with a meticulous sorrow, a labour of love and remembrance, constructed by an artist too young to have been part of, or to remember, any of the events depicted, but whose history has nevertheless been partly formed by them.

Studying the photography of the Holocaust, one becomes deeply aware of the presence of the dead, of their scattered possessions, their irredeemably interrupted lives, and of their continued presence in our culture, our politics and our everyday existence. The photography of these years, whether focused on happy pre-war days or tragic times of later years, is always difficult to look at. Prolonged viewing makes us question our motives for looking. Do we seek for evidence, for redemption, or for pain, or perhaps even for the reassurance that our own lives have some greater safety, that our photographs, unlike theirs, will reside safely in our drawers or our family albums, or close to our hearts in a pocket or a wallet? And do we, as Philip Gourevitch suggested when writing about his visit to the Holocaust Memorial Museum, think that we may become better people for having gazed into this abyss? Such questions are difficult to confront, impossible to fully answer.

Contemplating photographs made during the Holocaust, and in the years which followed it, we are able to make no easy claims, no comfortable art-historical analysis of aesthetics or appearances. These photographs remain an enigma, not easily assimilated into any recognizable pattern. To discuss them at all is troubling, to look at them, insistently, and over a number of years, even more so. Confronting this iconography, we are continually conscious of the millions of lives which have disappeared and, like amnesiac wanderers in a desert of memory, we can only attempt to imagine them.

THE MYTH AND THE MEDIA
Photography and the Vietnam War, 1968-1992

The war in Vietnam, real enough for the thousands of people who experienced it, has become a site of many fictions, of memories, real and half imagined. It has spawned Hollywood films, documentaries, autobiographies, numerous reports and surveys, millions of photographs and a crisis of confidence in the United States, discernible to this day.

At the Vietnam Veterans Memorial in Washington DC, visitors gather daily to read the names of those Americans who were killed. It has been said often enough that Vietnam was the first TV war, the first conflict to be brought into our homes as film live from the scene of the battle. In the 1960s, watching television became one of the western world's most compulsive pastimes, and the witnessing of televised war reports from Vietnam formed an important part of the ongoing drama which viewing provided. Along with the Beatles and President Kennedy, Vietnam became part of the collective memory of growing up in the 1960s. For those who were there, witnessing and taking part in the action, memories of the war persist in a more tangible way, and the damaged lives of Vietnam veterans and their families remain an engrossing issue in the USA.

After Vietnam, both the media and the authorities became more circumspect about the reporting of war. Those who control access to the war zones have become not only more careful about what the public is allowed to see, but also have more information about the effect of uncensored news on political opinion. The effect of 'pooling' (an arrangement between the authorities and the press which results in only a few photographers being selected to record major conflicts) has meant that photographers no longer compete with each other for the best shots, or the most daring exploits, and also that selected photographers feel 'chosen' and therefore anxious not to overstep the mark drawn for them by the military or state establishment. The Vietnam war, by contrast, was a mecca for war reporters, both accredited journalists and maverick freelancers. The lack of strict US rules on censorship and access led to photographers having virtually free entry to all the major battle areas. For those who wanted to encourage the American public to support the war, it was an error of judgement. Much of the

Left: From the series Portraits at the Vietnam Veterans Memorial, Washington DC. 1983-4. Judith Joy Ross. Silver print 8" x 10". Courtesy of the artist.

coverage which emerged, most notably in the later stages of the war, was hostile to the US war effort, and revealed, with an uncomfortable rawness, the plight of the Vietnamese people. In her 1989 book *Shooting War*, historian Susan Moeller has painstakingly charted the work of western photojournalists who worked in Vietnam, and has provided an invaluable analysis of the ways in which press attitudes towards American policy altered during the course of the war, and the administration's response. Moeller's analysis is particularly interesting when she charts the involvement of a younger, more critical group of journalists:

> Although the press believed in the American cause, the younger journalists, even during the first half of the 1960s, felt they could be critical of the direction and focus of American operations in Vietnam: they thought they could criticize the American government and military without being unpatriotic. In so doing, they took the first step towards an adversarial clique – but an adversarial clique that always operated from within the American tradition. By Tet 1968, certain journalists came to criticize the American government not for applying American ideology to the conflict in Southeast Asia but for *not* doing so. The press came to believe that by establishing American control of Vietnam, by killing civilians and by lying to its own public, the United States government had abandoned its own democratic principles and, not so coincidentally, was losing the war.
>
> But it took until the Tet offensive of 1968 for the print press to become thoroughly sceptical in its coverage of the war. (The electronic media remained 'strongly supportive' of American actions until after Tet.) Furious about having been misled during the beginning phase of the conflict, correspondents for the newspapers, magazines, and wire services believed that the previous wars 'uneasy' partnerships between officials and journalists had been unforgivably betrayed ... the reporters became cynical and independent by the simple expedient of keeping their eyes and ears open.[1]

Women photographers worked in South East Asia from the outset of post-1945 hostilities. French photographer Catherine Leroy became distinguished during the Vietnam war of the 1960s and '70s both for her daring, and for the strength of her news reporting. Another French woman, Christine Spengler, made moving documents in the early 1970s of the bombing of Phnom Pehn and of the departure of the American forces. The veteran South East Asian photojournalist Dickey Chapelle died while reporting in Vietnam in 1965. But in spite of women photographers' participation, no figure emerged whose achievements and status could be compared to those of Margaret Bourke-White during World War Two. Bourke-White's coverage of South East Asia was minimal; after contributing a major story on Korea to *Life* magazine in the early 1950s, she began to succumb to the pain and debility of Parkinson's disease. Her enforced withdrawal coincided with the ending of an era in war photography. The photojournalists who followed her in South East Asia were to take a more partial and acerbic view of the continuing conflict.

Bourke-White's biographer, the critic and historian Vicki Goldberg, has charted the growing

cynicism of photojournalists in the 1950s and '60s – the very generation of photographers who would, in their turn, document the war in Vietnam:

> After World War II, 35mm photographers began to explore more private states of mind. The culture was changing. In the fifties and particularly in the sixties, as McCarthyism choked off social documentary (which retreated into the magazines) and the Beat generation began its interior journey, photojournalism took on a personal cast ... Photographers of the new generation, from Diane Arbus to Lee Friedlander, Garry Winogrand, and beyond, after Korea, after McCarthy, after the civil rights marches, the early student protests and Vietnam, would celebrate the outsider and sing the angst of the mechanical culture rather than its romance. The grand vision of Bourke-White's work, its faith in mechanical and spiritual progress, was faintly suspect in a more cynical and uncertain era.[2]

If attitudes towards photography were changing rapidly during the 1960s, attitudes to women's emancipation remained more ambivalent. Ironically enough, the women who had been energetically encouraged during the 1940s to take up war work were now being reminded of their obligations to home and family. The pop culture of the 1960s, though appearing to emancipate women, was deeply chauvinistic. While women's magazines paid lip-service to the 'new woman', articles about women in 'unusual' (i.e. 'unfeminine') occupations patronised those they claimed to applaud.

In 1960s Britain, *Nova* magazine had proved to be a lifeline for many young women: with its punchy text, exciting photographs and dynamic layout, it introduced its own brand of feminism to women's magazines, concentrating on women who were active in their careers, who were forging their way forward towards something which, at the time, looked like equality. For many of its readers it was their first real introduction to the idea of women's participation in traditional male arenas.

But *Nova* took women's achievements and advances only partly seriously, giving accolades with one hand, patronising with the other. In 1968, Brigid Keenan interviewed 'five women who had volunteered for Vietnam' in a piece called 'Where the Hell do You Think You are Lady, Fifth Avenue?' It was a classic example of journalism which praised women's tenacity and boldness yet appeared to be equally determined to keep women in their place. The essay begins by emphasizing the danger of reporting back from the war zone:

> So far, two women reporters have been killed: Dickey Chapelle, a veteran correspondent whose jeep was blown up by a mine, and Felipa Schuyler, a Negro(sic) reporter whose army helicopter crashed in a Da Nang Bay.[3]

Keenan goes on to report how French photojournalist Catherine Leroy had recently been held captive by the Vietcong, and also to describe Leroy's wounding in the assault on Hill 881. But despite this, most of the women reporters described by Keenan are immediately divorced from a professional context and become ambitious waifs and strays in a strictly male world:

No one sends them to Vietnam. No one even asked them to go there. Unless they can persuade somebody to back them before they go, they pay their own fares out to Saigon in the hope that before the money runs out some newspaper or magazine will buy their stories. They have to build up their own contacts, arrange their own trips into the field, find their own accommodation … It's a lonely business. Though one of the things that can prompt a girl into doing something so drastic is a passionate desire to be her own boss, the day can dawn when she longs, for just once, to have someone to tell her what to do next.[4]

Threatened by danger, loneliness, financial insecurity and lack of contacts: Keenan presents these women as reckless and lost, and longing to be told what to do. They can also, if the worst comes to the worst, be killed. So what, Keenan asks, took them there in the first place? She saw the answer as being: 'A mixture of curiosity and restlessness; an urge to be part of the scene, plus a large helping of ambition.'

In the entire four page illustrated piece, not one of Leroy's photographs appeared; the women themselves were the products. Pictured as rebels, desirable but discreet, they become elusive objects of desire, both to the young women reading *Nova* at the time and to a patriarchal media industry.

The real heroes, or anti-heroes to emerge from the media coverage of Vietnam were men. In 1971, Magnum photojournalist Philip Jones Griffiths published his book *Vietnam Inc.*,[5] arguably the most important anti-war photoseries to emerge from the conflict. Jones Griffiths wrote the text as well as making the photographs, and both describe a battered population, a culture degraded and landscape despoiled. A caption to one of the photographs, of a group of Vietnamese children gathered around two soldiers reads:

More recently, in keeping with efforts to automate the killing, enlarged 'people-sniffers' slung under helicopters have been used. A 'positive' reading is intercepted by a second, heavily armed helicopter that follows and automatically lets off a barrage of fire at the indicated position. In this way, no human decisions have to be made: a pair of helicopters skim over the countryside, the second raining death whenever the first detects molecules of amino-acid breakdown products, whether from buffalo, Vietcong, or children taking a short cut to school.[6]

But despite its passion, *Vietnam Inc.* is a problematic document. Jones-Griffiths was a member of a powerful media establishment, a colonialist, if an ambivalent one. Books like these, and the self-flagellatory autobiographical writings of celebrated war photographer Don McCullin show an urge to disown the industry which made both men famous. In a recent issue of the British literary magazine *Granta*, McCullin (despite having several lavishly illustrated books of his war photographs published, and a major retrospective at the Victoria and Albert Museum) declared that:

What I'm doing is not art. How can I call it that? I'm stuck with a load of pictures of

humanity – suffering, dying, bleeding. These pictures come from a witness. I've seen prisoners captured, stripped naked and blindfolded, trembling at the knee before someone gives the order to fire. I've seen men dragged out of cells in Saigon at dawn to a market square before throngs of people, and a fire engine standing by to hose away the blood after the execution. I can't detach the image my camera produces from the images in my mind. I can't separate my photographs from their subjects. How can I talk of these photographs as art objects? These are real people. I have inhaled their suffering. [7]

If Jones Griffiths and McCullin showed the 'politically correct' face of photojournalism, then another group of male journalists working in Vietnam in the 1960s were quite open about the excitement and exhilaration of being in the war zone. The *Rolling Stone* writer Michael Herr and the British photographer Tim Page were both active in Vietnam. They saw themselves as buccaneers and mavericks, misfits in a misled society. Journalism and photoreportage provided an escape route from the ordinary and invested their lives with both glamour and fear.

Some years after the American military involvement in Vietnam ceased, Herr wrote in his 1977 book, *Dispatches*:[8]

In the months after I got back [from Vietnam], the hundreds of helicopters I'd flown in began to draw together until they'd formed a collective meta-chopper, and in my mind it was the sexiest thing going; saver-destroyer, provider-waster, right hand-left hand, nimble, fluent, canny and human; hot steel, grease, jungle-saturated canvas webbing, sweat cooling and warming up again, cassette rock and roll in one ear and door-gun fire in the other, fuel, heat, vitality and death …[9]

Herr's commentary on the war expresses a combination of abhorrence and fascination. War was disgusting, but it was also beguiling – an arena where fantasies of action and adventure came alive. For some, like photographer Tim Page, the fantasies were actually realized. Recollecting his killing of an enemy soldier, he uses the language of photography to describe a real shooting:

And they were still coming. Half-crawling, they staggered against the hail of outgoing fire. A sapper, clad in black shorts and webbing, rose 30 yards away to hurl bamboo-handled Chi-com stick grenades. Time stood still. No thought focused. I raised the carbine and let the three prescribed rounds go. It was rehearsed Zen, like knowing you're about to hit the shutter-release button and a superb frame is about to be frozen. I knew I was on target, I had to hit to stop him. This was no time for photography, infra red flash or time exposure. It was a time to fight, every man for himself. No time to produce press card or passport. He went down.[10]

War correspondents occupy an enviable position in both military and cultural history. They have the outsider's glamour and insider's information. They can see themselves, and can be seen, as distinct objects of desire. The reminiscences of war correspondents can emerge as a

confessional, a purgation of the sins of witness, and an admission of guilt.

The filmmaker, artist and theorist Martha Rosler, (whose own artwork *Bringing the War Home; (House Beautiful)* has made an important contribution to the photographic iconography of the Vietnam war) has observed:

> War photography as currently understood, taking pictures of victims, is of course exquisitely voyeuristic. It has become hard to know what to make of war photography since the transit time from the battlefield to the coffee-table book to the gallery wall has shrunk so drastically. Confusion between reportage and art, and the increasing speed with which one passes into the other, invites projection, diminishing the reality of the people depicted, jostled aside by the burgeoning fantasies of the viewer. Consider Don McCullin, a photographer of the extreme grotesque school of war imagery common in photos and comic books since Korea. McCullin, photographing brush wars of the 1960s and 1970s, had trouble telling war from a car crash, and the people he photographed from himself. "

War journalists are volunteer witnesses, part of a media industry which has not only a mission to inform, but a need to sell its products to a waiting public. The war in Vietnam was newsworthy and exotic and more easily commodified than say, the war in Northern Ireland could ever be. The war journalist as tragic hero is part of the mythology of war reportage. These correspondents, it is implied, have suffered for their reports and have a moral right, even an obligation, to communicate their experiences to a wider public. Such suggestions form a useful bulwark against implications of voyeurism.

Given all these qualifications about the nature of photojournalism, the fact remains that wars are remembered only by the way that they have been reported. The lack of skilled photoreportage emerging from the Falklands War of the 1980s means that that war has remained in our memories as language rather than as pictures. The Gulf War of the early 1990s is now remembered mainly as a series of televisual images of remote controlled weaponry. Contrast this to the stream of aesthetically compelling photographic images which emerged from the First World War, the Spanish Civil War, the Second World War and from conflicts in South East Asia, from Korea to Vietnam, and the change in practice and attitude is profound.

Throughout these wars photographers concentrated on imagery of the victims; many of which are ingrained in our cultural memories. Now fifty years after it was taken, Robert Capa's photograph of a soldier in the Spanish Civil War recoiling from a bullet shot is still reproduced. Likewise, Margaret Bourke-White and Lee Miller's photographs of the liberation of the concentration camps remain current iconography.

Today's public is more knowing about the meaning and influence of photography, and it is inevitable that the journalism made during the Vietnam war should now be assessed within a contemporary context. The way in which the war was brought directly into our homes by television informs Martha Rosler's remarkable photo collages – her challenge to the myth of reportage, *Bringing the War Home; (House Beautiful)* (1967-72/90).

From the series Bringing the War Home (House Beautiful). 1967-72, 1990. Martha Rosler. c.print 24" x 20".
Courtesy of the artist and Simon Watson.

Rosler's collages show suburban America gone awry. All the trappings of comfort appear in these works – a gilt framed painting, a kitchen decorated in modern style, a smoothly manicured lawn – but subversive elements invade these somnolent scenes. A wrecked Vietnamese village lies beyond the deck chairs on the terrace, soldiers in tropical kit make their way past washing machines and refrigerators, and the face of a victim, portrayed in black and white photography, has replaced a prized old-master on a drawing-room wall. It is as if a virus has worked its way into this wholesome world; like poltergeists, these unwelcoming presences invade the domestic calm.

Writing of this work in a 1991 issue of *Frieze* the critic Laura Cottingham remarks:

[the series] was an outgrowth of Rosler's participation in anti-war activities, a response to the artist's 'frustration with images we saw in television and print media, even with anti-war fliers and posters. The images we saw were always very far away, in a place we couldn't imagine'.

In this remarkable series, images taken from *Life* and other mainstream American magazines are re-assembled and then re-photographed, thus reconnecting two sites of human experience – which the media insisted on falsely separating ... Like Jean-Luc Godard's *Ici et Ailleurs* (1974) which connects French consumerism to the Palestinian struggle, Rosler's *Bringing the War Home* asks us to consider the real social and economic connections between our comfortable sofas and someone else's dead body. Rosler forefronts the false division between 'us' and 'them', between 'here' and 'there' and suggests that this separation is an illusion that we are economically and emotionally invested to maintain.

Though Rosler's work has an importance without regard to gender, it maintains a significant place within a tradition of women's artworks. Querying the place of women within the domestic arena is no new departure, but Rosler does more than this. By placing military figures within the shining and otherwise deserted neatness of the American ideal home she comments too on the importance of place and space, on the recognized theatre proper to specific locations. Rosler's piece is concerned with consumerism, whether of domestic or photojournalistic products.

Audiences of the 1960s and '70s consumed the images of the Vietnam war just as they consumed the furniture, wall decorations and domestic appliances of the post-Second World War boom. Deeply rooted in the American popular consciousness is the notion of the sanctity of home, the importance of property. Rosler's photoseries usurps an idea of comfort and privacy, introduces the danger of violation, as ordinary Americans watch television or cook in their kitchens. It plays on a universal fear of intruders, whether burglars in the night or some faceless foreign force.

Rosler's work is a telling contribution to the debate about the 'truth' of war photography. Along with artists like Sophie Ristelhueber and Deborah Bright, she has attracted a new audience which demands not only information about the past, but also a framework for revised

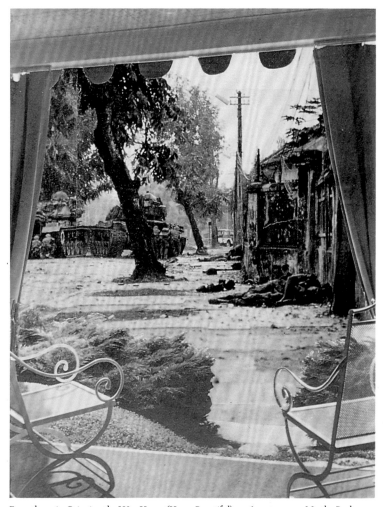

From the series Bringing the War Home (House Beautiful). 1967-72, 1990. Martha Rosler.
C-print 24" x 20". Courtesy of the artist and Simon Watson.

methods of studying the photographic image. The arrival of a new technology, which both enhances and threatens the stance of photography as documentary, and the concurrent possibilities inherent in computer imaging, has given artists greater opportunities than ever before to challenge the notion of the 'real world'. Art critic Brian Wallis, writing in *Art and America*, has noted that:

> Rosler's 20-year-old images seemed surprisingly timely in the issues they raised about photographic representation and how it affects our perceptions of reality. While computer enhanced video tapes of smart bombs effortlessly tracking and painlessly exploding their targets made the Gulf War seem fictional and distant, Rosler's photomontages invert this perception, matching scale, colour and perspective to make a horrific imaginary situation appear 'authentic'. The first image in the show, for instance, showed a young GI in fatigues seated on the neatly cut lawn of a suburban tract house. This casual insertion of war into the

pristine suburban locale is only slightly unsettling, with the soldier ambiguously signalling both protection and danger. Other montages were more melodramatic in their juxtaposition, showing elegant interiors 'invaded' by war refugees – one, a young Vietnamese girl with an amputated leg, another a Vietnamese woman carrying the body of her dead child up the stairwell of a split-level house.[12]

In her recent essay 'News and Views of War' Rosler observes that:

In the American adventure in Vietnam, although censorship could not be imposed because war was declared, the military tried to control the information and the language surrounding events and images. War was increasingly portrayed as a proving ground for men, not against a background of the domestic world, but rather as a male-bonded Rambo society permanently cut off from uncomprehending civilians. Ironically, perhaps Vietnam was the Living-Room War, the first struggle shown regularly on television. As network chief Richard Salant explained, television coverage arranged the material into short narratives on principles

From the series Portraits at the Vietnam Veterans Memorial, Washington DC. *1983-4.*
Judith Joy Ross. Silver print 8" x 10". Courtesy of the artist.

of drama. Networks routinely used 'generic' footage to fill in the visual gaps, and important stories were suppressed for lack of appropriate footage. This problem of transmission – the inconvenience of transmit time – has now been solved by replacing film with data, via video and satellite and phone wires. Even photographers no longer need film. Transmission and flow, not stillness, bring us the meaning of war.[13]

If Rosler's *Bringing the War Home (House Beautiful)* provides us with a more satisfying polemic about Vietnam than the work of photojournalists, then Judith Joy Ross's recent series *Portraits at the Vietnam Veterans Memorial, Washington DC* (1983-84), provides a logical corollary. Judith Joy Ross is an American documentarist living in Pennsylvania. She first came to public and critical attention with her photographic series, *Eurana Park* (1982). The series consisted of photographs of children who Judith Joy Ross encountered in her neighbourhood. Ross studied these children with an intense gaze, producing images which imply danger, and a barely concealed violence. *Eurana Park* was a study not so much of childhood, but of our feelings, as adults, when we are confronted by it. It was an exploration of loss, a probing of the territory which lies between innocence and experience.

Though their subject matter was ostensibly very different. Ross's subsequent photo series, *Portraits at the Vietnam Veterans Memorial, Washington DC* (1983-84) explored the same psychological territory as *Eurana Park*. The series became another kind of elegy, and Ross has remarked: 'I made these portraits because I wanted to find out what other people and what I thought of life … How does one deal with the pain and injustice of this world?' Watching and photographing the visitors to the monument, Ross asks pertinent questions about our need to look, our compulsion to read the names of the dead, to bear witness. The people she photographs are very ordinary voyeurs. We do not know their reasons for gazing at this vast edifice, and Ross does not try to explain them. If the people in her photographs appear dislocated and severe, then perhaps it is because they are spectators at an inexplicable event, uncomprehending readers of a list of the disappeared.

The 'normality' of the people in Ross's photographs is startling. We could see them anywhere, in a shop, passing by in a street, driving their cars, without taking any notice. They gaze at Ross and her camera with what is either incomprehension or disinterest. There is no reason, they seem to suggest, for them to be photographed by this stranger, and their poses and expressions show both bewilderment and a bland acceptance of the process of being portrayed. In one photograph, a boy stands in the rain, his hair covered by a woollen helmet. He is a desolate figure, his face creased into a grimace, isolated in his own space, absorbed in his own thoughts. This portrait, more than any other in this acute and powerful series, expresses a national angst, a sense of America's dislocation and dysfunction.

In 1985 New York critic Max Kozloff visited *New Photography*, a group exhibition at the Museum of Modern Art which included Judith Joy Ross's photographs. Writing of the *Vietnam Veterans Memorial* series, he remarked:

From the series Portraits at the Vietnam Veterans Memorial, Washington DC. 1983-4. Judith Joy Ross. Silver print 8" x 10". Courtesy of the artist.

Such a locale is quite obviously public ground. People from many walks of life go there in observance of a historic and national trauma, signified by the inventory of the engraved names of thousands of killed soldiers. What we see in Ross's photographs is the product of time taken out from that visit, and yet the gravity of the event still resonates in faces. The young man with the crew cut and hooded boy, his mouth open, know themselves to be portrayed, a knowledge reflected in their stance before the tripod camera, but their minds are not altogether centred and alerted to the fact – and Ross slips into their reflection.[14]

In the making of her photographs, Judith Joy Ross has expressed a trenchant statement about how we regard our own histories. Each visitor to the Memorial has an agenda. Some will come to visit as part of a tourist itinerary, for the Memorial, like President Kennedy's grave and the doorway of the New York apartment block where John Lennon was shot, have become part of the leisure industry and part of America's heritage. Others will visit for more personal reasons, to pay homage to the dead, and to remember. Many will come in an attempt to understand, hoping that this votive place will provide a clue to the past, and to the catastrophes of world politics.

Judith Joy Ross's photographs are themselves a kind of memorial and, in the passage of time, memorials are all that remain of war. We use them as a store for our memories, to give us precise information of a very factual kind. We visit them as spectators of the past, as voyeurs, or as worshippers at a shrine. Photographs can act as memorials too; fixed in our memories and on the printed page, their resonance alters as time passes and opinions change.

The Vietnam war, recorded long ago by young photojournalists, speculated upon by historians and critics and reworked by artists and photographers in recent years, remains a focus for our attentions, and a touchstone for our contemporary experience. Vietnam is a cultural and social riddle, its representations, and the motives of those who have made them, are controversial, conflicting and deeply ambiguous.

THE UNREDEEMED PAST
Enigmas of Collective Memory, 1980-1992

For those born in the post-war years, photographic explorations of personal histories have become prolific. As opinions on our recent history shift and previously suppressed information becomes available, postmodernist autobiographical work has become common practice. Many artists have begun to produce artworks which, using visual images, texts and oral history, challenge the hegemony of both formalism and modernism. They have constructed personal narratives which confound and challenge the veracity of traditional historiography.

In 1990, the Japanese-American photo artist Masumi Hayashi returned to the abandoned buildings of her birthplace at the Gila River Relocation Camp in Rivers, Arizona (after the enforcing by the US government of Executive Order 9066, a reaction to the bombing of Pearl Harbour, which confined Japanese Americans living on the West Coast to remote camps). From her visit, Hayashi produced fantastic landscapes of bizarre structures and distorted perspectives. These emerge as a distillation of lost memories and represent a past unredeemed by experience. Writing of her work, she says:

> The *Gila River Relocation Camp* photo collage symbolizes another point of passage and transition for Japanese Americans. This place is a personal memorial of my birthplace. It also represents a time when Japanese Americans were placed in concentration camps during World War Two.
> All of these buildings are abandoned; some are in a state of decay. My photographs of these sites depict simultaneously the grotesque and the beautiful. Ironically, sometimes the colour in the photograph makes the subject matter romantic, in spite of the implication of their more disturbing functions. Some evoke the feeling of archaeological ruins and a sense of history. Having been born in a relocation camp, there is a personal fascination with my own past within these sites. The process of locating and photographing each site has become a special journey and a special memorial.[1]

From the series Every One. Sophie Ristelhueber. 2.7 m x 1.8 m. Courtesy of the artist.

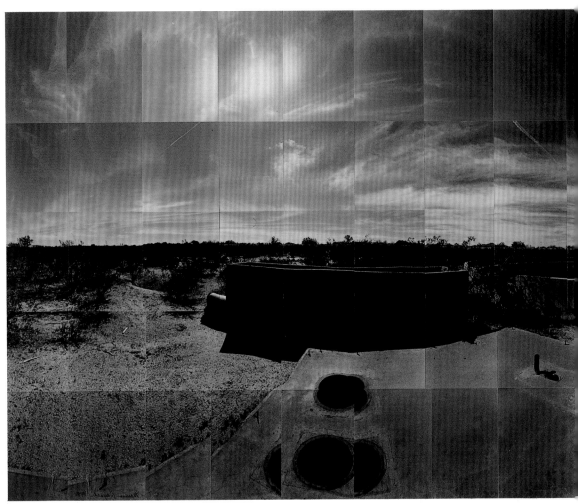

Gila River Relocation Camp. 1990. Masumi Hayashi. Panoramic photo collage. 22" x 66". Courtesy of the artist.

Contemporary data, some of it photographic, concerning the Japanese-American internments of the 1940s, is also in wide circulation in the United States. Historian Brian Niiya has made an extensive study of conditions in the camps[3] and the photographic documents of Dorothea Lange(1895-1965) and Hansel Mieth (b.1909) exist as a testament both to the forced removal of Japanese Americans from the West Coast and to their internment. Dorothea Lange brought to the project her experience of photographing poor migrant workers in Dustbowl America in the 1930s. She photographed Japanese Americans throughout their internment with the concern and compassion which had made her rural photographs for the Farm Security Administration (FSA) so outstanding.

Lange's photographs, taken for the US government's War Relocation Agency, are highly evocative studies of families in their environments, backed up by biographical data and information about housing, transport and employment, in the form of written captions. Just as she had done while working for the FSA, Lange focused on old people and infants, bewildered and overawed by the force of their circumstances. No one doubts Dorothea Lange's position as

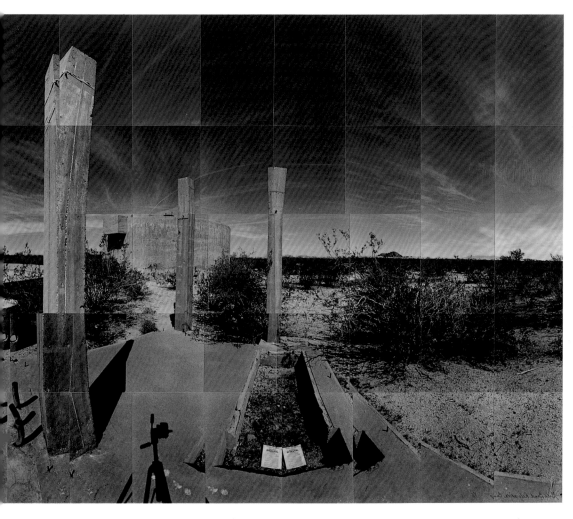

a social campaigner. What is of interest is the way in which the methodology of poetic social documentary could be adapted to fit each and every differing circumstance. The situation changed, but the picture-making remained the same.[4]

Separated by five decades, the internment camp photographs of Lange and Hayashi could not be more different. While Lange acted as a reporter, describing conditions and photographing people, Hayashi's work is concerned with collective memory. In her search for her heritage, Hayashi has also recorded extensive audio interviews with Japanese Americans, and remarks on this process:

> The collective voice itself is creating its own direction with each additional interview. Congress had admitted its mistake during the 1980s with its approval for redress. President Reagan has apologized to the Japanese-American people. Time has released the repressed feelings of these people (the Niseis, the English speaking, second generation), released an openness and willingness to pass on their stories, emotions, experiences, regrets, and final perspective on their lives.[5]

History, remembered through statistics or witness statements, conveyed by contemporary photographs and accounts, together with a knowledge of family lineage, all feed into Hayashi's artworks. Her photocollages bend perspectives and alter structures just as time and memory affects the ways in which history is perceived. In *Gila River Relocation Camp*, the remains of the camp emerge from the desert as primitive and votive symbols, the remnants, one might think, of some ancient tribe whose civilization had persisted in this barren place. In *Minidoke Relocation Camp, Visitor's Waiting Room* (1992) two bleak towers form the opposing pillars in an arching detritus-strewn landscape. Indications of the people who once lived there have almost disappeared.

Skilfully subverting a traditional iconography of prison camps, rendered ultra-lifelike in a hundred Hollywood films, the work challenges a sense of documentary rightness. Hayashi has altered reality by the process of using photography and collage, and has made an ironic fable of a real event.

Important too in the use of photography as autobiography is the work of British photographer Jo Spence (1934-92). Born in London, the eldest child of working-class parents, she was evacuated at the age of five to the English countryside. In her adolescence she trained as a secretary, and entered photography as a clerical assistant at a commercial London studio. After operating her own studio in the 1960s, she allied herself with the burgeoning radical photography scene in 1970s London, exhibiting her startling show of self-portraiture/family photography, *Beyond the Family Album* at the Hayward Gallery in 1979.

By the early 1980s, Spence had begun to produce *Photo Therapy*,[6] in which she explored her personal history and identity. One of Spence's early picture series in *Photo Therapy* was an exploration of her own childhood during World War Two, seen through her relationship with her mother. Writing in her 1986 autobiography, *Putting Myself in the Picture*, she revealed the feelings of loss and abandonment which she was working through in her photo therapy series:

> Even when I researched representations of women in World War Two and found that mothers were encouraged to send their children away by the state, I never got anywhere near my anger towards her. As a piece of research, it could never deal with the fantasies and pain around being sent away ... I next became my mother in the war, the mother I left behind when I was sent away, a war worker with a life of my own. So the first shots I did were of my mother making the sandwiches which I had never thought of in years. Then I passed on to her at work in a boiler suit and turban – straight into stereotyping because I never saw her at work. I began to feel that for her, work was a release from home into the comradeship of women.

Spence used photography to range freely through her family history. That the catalyst for the uncovering of this domestic story lay in the social and economic disruption of World War Two is highly significant.

Another London-based artist, Al Johnson, has considered the effects of war and empire in a

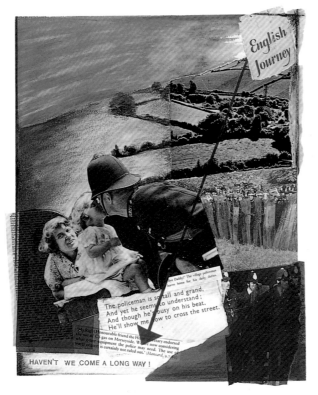

English Journey. 1992. Al Johnson. Collage and drawing. 16" x 20". Courtesy of the artist.

meticulously political sense. Constructing boxed works, a parody on the morbidly preserved glass-cased birds and animals of the nineteenth century, Johnson makes assemblages of photographs and objects which take us back into a world of dimly remembered things – Ovaltine and Union Jacks, family albums and wartime propaganda notices. Johnson is an experienced community oral historian, and has spoken with many older women about their memories of the Second World War. These remembrances have informed her artworks, leading her to juxtapose and position objects and photographs in very particular ways. They are a re-arrangement of history, a satire on our reverence for the past, tiny reminders of drabness and of hope. As one commentator has remarked:

> She evokes a quintessentially English world of sheep 'safely grazing' and traditional chemists' shops; of St Paul's Cathedral and bomb sites garlanded with rose-bay willow. Yet her 'boxes' also challenge the complacent militarism and commercial greed of that world.[7]

For Anne Noggle, another major woman photographer of the 1970s and '80s, the process of remembrance is equally significant. Noggle had been a WASP (Women's Airforce Service Pilot) in the United States during the Second World War, and continued to work in aviation until she took up photography in the early 1970s.

As a photographer, and teacher of photography at the University of New Mexico, she became distinguished for her 1970s self portraits made during and after cosmetic surgery, and

for her documentation of older women. Noggle's work has an incisiveness and a rawness which has established her (along with workers like Jo Spence, Cindy Sherman and Helen Chadwick) as a major directive force in contemporary photography. In the autumn of 1986, Anne Noggle attended a reunion of former WASPs in Sweetwater, Texas. She had decided to photograph her former colleagues and explained her motivations:

> Since 1979 when Congress retroactively determined Women Airforce Service Pilots to have been in active military service during World War Two, public curiosity suddenly brought us from obscurity to the limelight. Until that time, except among pilots, few knew we had existed. Now that we were established as the country's first women military pilots, everyone seemed to know who we were, but beyond that they had only vague notions of our endeavours … I wondered if we all perhaps shared similar traits of character that made us go do it. That led to ruminating about how we look today, some forty years later. Could you tell, I smiled, that we came out of the Wild Blue Yonder?[8]

As well as photographing the WASPs forty years on, Noggle compiled a record of photographs made at WASP bases during World War Two and published both sets of work in her 1990 book *For God, Country and the Thrill of It*. The combination of those 1940s snapshots, innocent, detailed and sublimely casual, and Noggle's stark, intelligent studio portraits from the 1980s, introduces a set of questions about the function of portraits in our histories and the ways in which we construct archives, both real and imagined, to codify memory. By looking back at the photographic record made during the mid-1940s at WASP bases, Noggle establishes a context of remembrance which enables us, many years later, to contemplate this very singular women's world. For her, the act of re-encountering history is important:

> I am standing here in Sweetwater, here on what was Avenger Field, here in the wishing well where I was tossed after I soloed forty-five years ago, here physically in my own footsteps with the same sky above, the wind still quick and shifting, the sound of airplanes still here, though with smaller, tighter voices – and yet there is this wrenching in my chest as I fill with remembrance. I try to leave the here and now and make that one journey it is impossible to make – to live it again, not just to relive it. I have returned with my classmates and we collect on the ramp and have our picture taken – we, smiling at one another, in the face of our friendship, in the ease of our comradeship, knowing our courage but never speaking of it, bonded beyond belief. The class of 44-1. That is how we were known then; that is our mutual identity.[9]

The youthful women Noggle illustrates with archive photographs were excited by their new role and new freedoms. In one photograph, a gathering of trainees pay 'playful homage' to an aircraft; in their zoot suits and turbans they both satirize and worship the power of the war machine. In another, a group of women, laconic in boots and leather flying kit, lounge elegantly, waiting for their turn to fly. For these pictures, casual as they might seem, are full of

glamour; ordinary young women from all over America, they become look-alikes of Rita Hayworth, Jane Russell and Marilyn Monroe. Legends in the making, they have a supreme and touching sense of self-worth.

Such is the nature of the snapshot that there are no grim realities in these photographs, no sexism, no hierarchies, no corruption, no discomfort, no disappointment. So it is inevitably a partial record, more a love letter to history than a documentary record of the here and then. 'Here is that past' writes Noggle tellingly, 'sometimes more real than anything since.'[10]

Seen alone, these photographs would have been little more than sweet nostalgia, but Noggle's visual codicil, her contemporary portraits of the 1986 WASP reunion, add a startling addenda to her narrative of times past. Made against a blank background, her 1986 studio portraits of her wartime colleagues act as a counterpoint to the 1940s snapshots. Here is youth and beauty turned into old age, zoot suits and snappy turbans become slacks and permanent waves, slim bodies have thickened, the fierce gazes of youth tempered by experience to the quizzical stares of late middle age.

But Noggle does not make dowdy clowns of her subjects; these women have dignity and humour: they smile, they gesture for the camera, they are partners in the exercise of remembrance rather than the objects of a voyeur's stare. For Noggle, the act of photographing

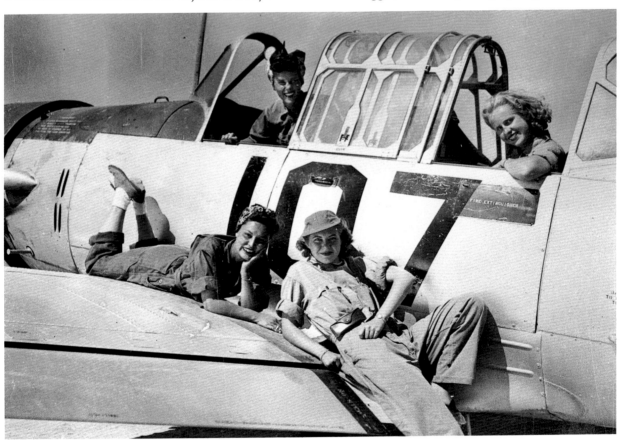

Off Duty WASP trainees posing with their intermediate trainer, the Vultee BT-13. World War Two. Archive photograph. Courtesy of Anne Noggle.

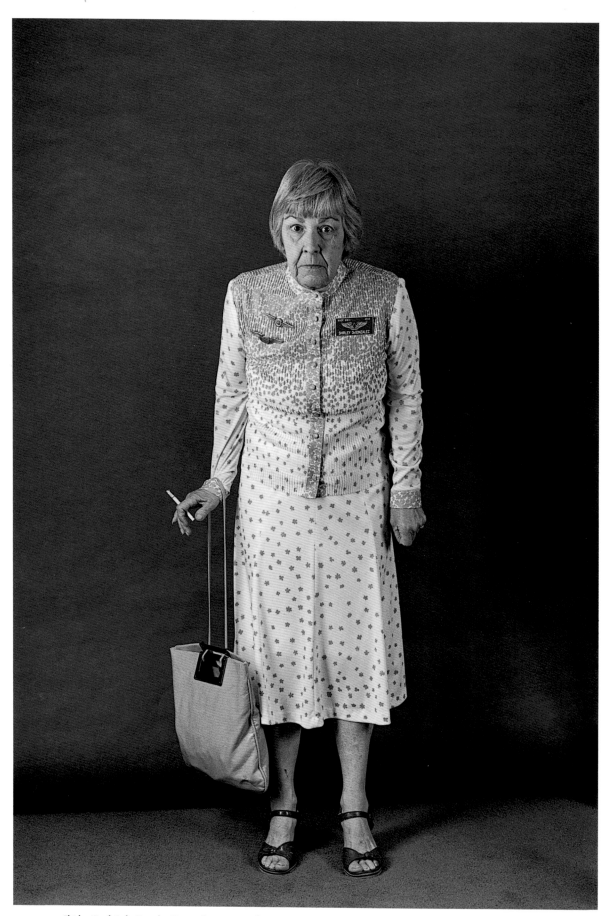

Shirley Conduit de Gonzales. Portrait by Anne Noggle. 1986. Courtesy of the artist.

becomes also an act of homage.

'So here we are again in this endeavor,' she wrote in 1990. 'And the similarity between us all? We have all loved airplanes, and the sky in which they truly live. What else? We are all individualists, and we have had to put ourselves on the line – and we did it for God, country and the thrill of it.'[11]

After photographing the WASPs reunion, Noggle decided to seek out, photograph and interview women pilots in Russia. She photographed 'one dive bomber regiment, the 125th, a night bomber regiment, the 46th and a fighter regiment, the 586th.'[12] As front line combat troops, these women had undergone a more hazardous war than the WASPs, and the privations of their wartime lives had been severe. Nonetheless, their common experience, their equal age, their perception of themselves as women, made once again for a communality, as they sought to explain a past life, through the medium of photography.

Landscape forms the coda of French photo-artist Sophie Ristelhueber's series of photographs of the war-damaged city of Beirut, made during the 1980s. Many women war reporters have photographed in Lebanon's capital: French photojournalist Christine Spengler came to Beirut after extensive reportage in Vietnam, El Salvador, Iran and Northern Ireland; Finnish photographer Leena Saraste produced *For Palestine* in 1993, documenting the suffering of the Palestinians in Lebanon.[13] In a 1984 Spengler photograph a young boy in a striped pullover points a machine gun, in Saraste's *For Palestine* distraught mourners gather at the grave of a loved one. These images are the familiar ones of the war reporter, the incongruity of the child guerilla, the sorrow of the bereaved. Both women operate within a system of signs which we can easily recognize.

By contrast, Sophie Ristelhueber's 1984 architectural studies of Beirut[14] are unpeopled, there are no survivors and no dead, only the buildings themselves, torn apart by bombs, crazily askew, bullet-holed, broken, and enormously beautiful. (*Illustration, see page 6*). Like Gaudi cathedrals worked over by an even more fantastical hand, they erupt, passionless structures in a calamitous era. In this silent, ruined world, Ristelhueber is an inquisitive explorer stumbling across what seems like some ancient and undiscovered site. Taking Beirut away from modern times, she relocates it in some mysterious past, and invites us to speculate as to its place, time and inhabitants. That we know its real location, its real history, makes her study perplexing and enigmatic; we look on with curiosity, only to find that our presence as spectators at the arena is subtly challenged.

Ristelhueber's photographs dislocate and fragment our perceptions of the real: could this bricked-up and smashed house next to the seafront really have been the Restaurant Bahri, and did that jumble of concrete and torn wire truly have a former life as a sports stadium? It all seems open to question. Though we are accustomed to photographs of cities destroyed by war (London, Dresden and Warsaw were all fully documented during the Second World War), Sophie Ristelhueber's *Beirut* takes this traditional iconography and subverts it, transforms it into a beguiling architectural spectacle, confounding traditional notions of what war photography is, or should be.

From the series Fait (Aftermath). 1992. Sophie Ristelhueber. 1 m x 1 m 30.7 cm. Courtesy of the artist.

Likewise, her photographs of the Kuwaiti desert, made shortly after the end of the Gulf War, and published as *Fait* in 1991 [15] concentrate on the spaces of war rather than its participants. Many of the photographs in *Fait* were made from the air, they show marks and pathways through the desert, peculiar tunnellings which, from above, look like the workings of some determined desert creature. The photographs appear almost as maps, devoid of horizons or boundaries, decipherable only by the marks that men have made. They are crazy landscapes, illogical and misformed, freaks in what was once, perhaps, a perfect world. These spectacular photoworks contain a trenchant moral message, and Sophie Ristelhueber casts a stern eye on men's deeds, making satires of the fractious meanderings of their high technology. Seen from the air, the surface of the desert appears as a cancerous skin, deformed and ridden by eruptions. Like maverick cells seen through a scientist's microscope, they are ominous parts of our natural body.

Walking through the battlefields of the desert, Ristelhueber photographed the detritus of war. No dead bodies, but instead a shattered crate, slowly being overwhelmed by sand, a chain like a monstrous metallic centipede, an engine burst apart like a broken and swollen corpse. Most remarkable of all perhaps is her aerial photograph of a line of trucks, cars and lorries, destroyed by firepower at the end of the Gulf War. They seem to be the only remaining signs of a lost population, ruined by flame when a communal clock stopped. Ristelhueber's

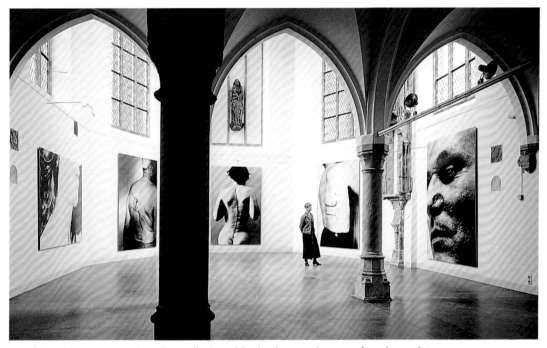

View of the installation Every One *by Sophie Ristelhueber. Exhibited at the Centraal Museum of Utrecht, March-June 1994.*
Courtesy of the artist.

photographs open the door to a chamber of catastrophes, to Caliban's haphazard cave, to the bedlam of war. Calmly, she invites us to take a look inside.

Sophie Ristelhueber's most recent photographic series, *Every One* (1994), is an even more oblique statement about war. It is a collection of large-scale black and white photographs of wounds and abrasions to faces and bodies, made in a military hospital in Paris in 1994. There are no clues provided by Ristelhueber about the nationality of the people she photographs, or about the cause of their injuries, but her juxtaposition of the photographs with text from Thucyidides's *History of the Peloponnesian War* positions the work firmly in an area of conflict. The people Ristelhueber photographs have been violated and damaged, and she studies their features and their skin with a meticulous eye; each abrasion is noted, each crudely made stitch recorded. There is no drama in these photographs, save that provided by their subject matter and the dramatic scale of the works. They are quiet scenes, redolent with pain. *Every One* is a peaceful contemplation of violence and disfigurement. It speculates on the vulnerability of the physical body, setting this in direct juxtaposition to the idea of a military 'science'. Ristelhueber reminds us that war is neither science nor art, but a crushing of skin and muscle, a cutting and tearing of the skin, the making of outlandish patterns on a perfect surface. In 1994, *Every One* was installed in the chapel-like gallery of the Centraal Museum in Utrecht. Ristelhueber hung her work against the ancient white walls of the gallery; larger than life-size, the photographs dominated the space and the audience who came to view them. Above the installation hung a crucifix, part of the Museum's permanent collection, and the tiny wounded Christ figure looked down on Ristelhueber's modern maimed giants, creating yet another enigma.

Following pages:
From Hotel Polen. 1986. One part of an 18 piece installation by Ania Bien. Gelatin silver prints 76-3/4" x 48-1/16".
Courtesy of the artist.

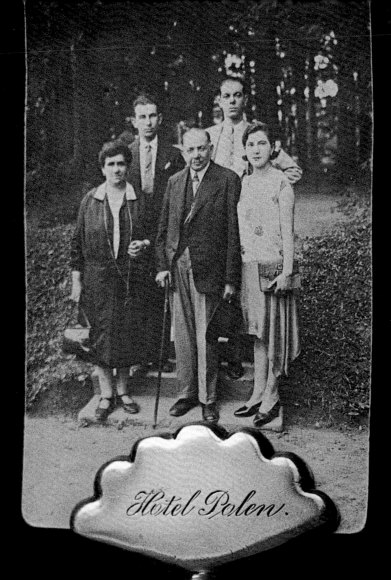

Hotel Polen.

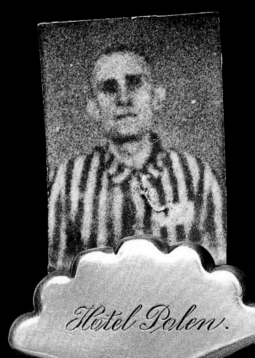

IT'S A MAN'S WORLD
Photography, Fantasy and Fetish in the 1990s

War photography has always been a parody of real war. Yet ironically, we rely upon it as a major source of information about world conflict. Within a dramatic framework of action, war photographers construct and play out a particular and highly specific scenario. War reportage, though it aims for objectivity, always has a point of view. As a genre, it has many roles and many meanings. War reporters act as witnesses and become choreographers, they are part of a media industry, yet also show their photographs in the context of art galleries and publications which aim to explore an aesthetic as much as an event. War photographers as a group and as individuals attract much attention. Unlike food photographers or portraitists, their memoirs are much in demand. In an age in which the media dominates so much of our attention, they have become heroes of a very particular kind. We know more about war reporters than we know about the soldiers who fight the battles.

War reporters are often dignified or excused by their courage. In our contemporary imaginations they have a certain glamour. As we sit, seemingly safely, in our home or workplace, they can become our alter egos – always on the right side, they photograph strife and calumny, but with the consciousness of sorrow, informing their images with a romantic angst. Although much of our information about war now comes to us via television, war photographers can still be seen as accredited missionaries of a caring intelligentsia. Elevated, through exhibitions and monographs of journalism and art, their images inflame our imagination and stir our consciences, at the same time fulfilling our aesthetic needs.

Like looking at pornography, looking at war photography can be an experience exciting enough to be problematic. Women war photographers have always provoked a particular frisson and it is not coincidental that many of the most successful have, in the past, emerged from fashion and advertising photography. Margaret Bourke-White, photographed during World War Two, stands leather jacketed in front of a US Army plane, long haired, lipsticked and glamorous, Hollywood star and warrior queen combined.

For many women working in the battle zone, the very fact of their having been there,

Seductive Myths 1. From the series Men in Uniform. Moira McIver. 1992. C-type print 23" x 19". Edition of three. Courtesy of the artist.

solitary female figures among a mass of men, is titillating. In their war correspondents' uniforms, their vulnerability and femaleness is emphasized. They are the ultimate Other. Their courage and determination stands out more markedly because we are aware of the difficulties of their position, the barriers which they have had to surmount to become part of the very male world of photojournalism. Through historical accounts and biography, their achievements are highlighted and further ennobled: a glamorous woman in a man's world is always an enticing subject, provoking praise, disapproval, envy and huge public interest. Moreover, the 'woman's eye' is relied upon to produce something very special – a vision which is more compassionate and more attentive to the human condition. Although history proves repeatedly that this is not the case, its consumers retain their expectations.

War has become part of our everyday lives. We are aware of the many conflict zones throughout the world, and the power of mass communications has ensured that we have a knowledge of world events denied to us even fifty years ago. Yet the mass media, by a process of news management, increasingly distances these events from our lives. Brought to us by television, war seems merely part of an ongoing drama, scarcely believable, easily forgotten. Three contemporary women artists working with photography, Anna Fox, Moira McIver and Barbara Alper are among those who have confronted some of the fictions and fantasies engendered by war, who have looked at war as gameplaying, as media product, as a vehicle for dream and desire.

Their works are interrogations of accepted methodologies of war reportage. Anna Fox uses colour documentary to portray weekend wargames, played as if for real. She employs considerable irony, inviting us to find meaning within the ambiguity. In her photographs there is an underlying satire, not only of the people she photographs, but of the society in which we live, and of the conceits of photography itself.

In her photo series *Men in Uniform*, Moira McIver challenges our perceptions of militarism. By presenting soldiers, half undressed, vulnerable and possessed of a sexuality often associated with women rather than with men, she asks important questions about our relationship with signs of power and authority, inquires into issues of gender, subverts the politically correct by quizzically examining what women like to look at, and their reasons for looking.

Barbara Alper, in *Gulf Channel* (a series of images taken from the television screen at the time of the Gulf War), makes important comparisons between the actuality of war and its appearance in the media. Like Anna Fox and Moira McIver, she too explores the notion of photographer as voyeur, and audience as consumer.

All three, in widely disparate ways, look at war and militarism as systems of power and control. But more than this, they look at the position of women in a very male world; they dispute received iconography and use their photography to present different truths. It is a common supposition that women work only in opposition to the received, but many women war photographers work according to the same rules as men and produce the same kinds of photographs. The women whose work we are considering here have, in the main, abandoned

or subverted establishment parameters. But their work has been made, not just to present an alternative to a conventional history, nor merely to dispute the truth of photoreportage. They have looked at war and at the social catastrophe it produces in order to present what they see as important truths about society, and also to seek out the many different meanings which the photographic image can convey, the multiple ways in which it can be used. History is fact and event memorised and interpreted, and if women are more cognizant of this, then perhaps it is because as relative outsiders in a society where the rules are still made by a male establishment, they have always needed to look beyond the traditional, beyond the product and beyond an established audience to convey their views.

In 1987, Anna Fox, recently graduated from the pioneering photography course at West Surrey College of Art and Design, made *Workstations*,¹ a witty and often acerbic photographic narrative about office life in the South of England. In *Workstations*, the world of the office emerged as secret and tribalistic, a mannered society with strict codes and established rites. The parameters of the project were clearly defined, office workers were pictured only while at work; divorced from domesticity, they create an enclosed fraternity which operates in accordance with custom and tradition. These salesmen, secretaries and managers observed a hierarchy so entrenched that its rules need not be written or announced. Moving through an angular landscape of desktops and wordprocessors, these neatly dressed and unassuming workers controlled the anarchy of corporatism.

After completing *Workstations* Anna Fox began work on *Friendly Fire*, a study of the weekend wargames which now form an integral part of the British leisure industry. Just as *Workstations* had probed beneath the calm surface of office life, presenting a finely-honed comedy, so *Friendly Fire* wreaks havoc with our reverential notions about the nature of war reportage, and subverts the status of war photographers.

Fox's work was perhaps a logical progression from British photodocumentary of the 1970s, when photographers developed an anthropologist's fascination for the eccentric configurations in the world of hobbyism. From the 1970s and throughout the 1980s, their satire of the English penetrated deep into a British predilection for eccentric and escapist leisure pursuits. Ranging from studies of the stiff-frocked, rhinestone-encrusted princesses of ballroom dancing, to the mysterious Northern enclaves of pigeon fanciers, these photographers made highly whimsical documentary portraits of the British at play. Many photographers looked to the North of England for their subject matter, concentrating on the clubs and societies formed by urban working-class people, emphasizing the ritual nature of what seemed, even in the mid 1970s, to be a quaint, idiosyncratic way of life. By the 1980s, this mannered social satire had been replaced by a bleak portrayal of a nation enthralled by consumerism – supermarkets, shopping centres and show houses became centres of attention. Neither glamour nor nostalgia had any place in the schema, and innocence was lost. Photographers like Anna Fox, Nottingham-based Nick Waplington, Irish documentarist Anthony Haughey and Yorkshire-born Paul Reas, all working in bright, often flashlit colour, began to question not only the elegiac nature of the elegant

From the series *A Serious Escalation of Events*, part of *Friendly Fire: Weekend Wargames in Britain in the 1990s*.
Anna Fox, 1992. C-type print 50" x 40". Courtesy of the artist.

photodocumentaries of the 1970s, but also the philosophy which lay behind them.

When Anna Fox began her photographic career in the early 1980s, this deconstruction of documentary in British photography had already begun. The notion that reportage could tell some unchallengeable truth was itself challenged. The growing importance of women who were examining questions of gender and identity within photography set a vibrant new agenda during the 1980s. In Britain, women as diverse as Helen Chadwick, Jo Spence and Mari Mahr traversed the 'real' and made complex and intriguing statements about the world around them. And in departing from the orthodoxy of documentary, a context was made for photographers such as Anna Fox to devise a new strategy of reportage.

While Anna Fox was making *Workstations*, she learned of the weekend skirmish and 'paintball' games which were fast becoming a voguish leisure activity for young British men (and a very few women), made prosperous by the economic boom of the '80s. The photographs which she then began to make formed a fascinating departure in British documentary work.

By substituting pretend war for the real thing, Fox posed questions, not just about the nature and parameters of war photography, but about the probity of documentary itself. In her pictures, which depict young British men (often office workers) playing war games at the

From the series The Dead, part of Friendly Fire: Weekend Wargames in Britain in the 1990s. Anna Fox, 1992.
C-type print 50" x 40". Courtesy of the artist.

weekends in the countryside of Southern England, she presents a narrative of what *looks* like war, a frantic melee of uniforms, guns, trenches, mud, fear, violence and panic, but which is really just a game. By confronting these bizarre soldiers *manqué*, fighting mock (but often frighteningly 'real') battles on the pastiche battlefields of a claustrophobic semi-rural England, Fox has assembled a series of motifs and pictorial codings which are instantly recognizable, but because of their origins, baffling and disorientating. The result of her picturing is a black comedy which portrays a distraught, erratic male drama, a sterile and contextless longing for virility and invincibility. It is a multi-layered story of a stressed society, stranded in a terminal state as old values of valour and strength become entangled with newer ones of leisure and reenactment. Half-remembered wars, reconstituted as games, become a substitute for the real thing.

From the beginning of her study, Fox was engrossed by the structure of this make-believe world. The games are played on land which has been declared surplus to requirement by European Community agricultural policies, or in the derelict hospitals closed during the reformist zeal of the Thatcher years. The sites are haphazard and incoherent reconstructions of notorious war zones, jumbled together as history is plundered: 'there are World War Two jailblocks and a lot of sites have a Vietcong village and a River Kwai bridge.'[2] Recycled by an

ailing leisure industry, from the transmitted memories of television and films, the sites are removed from the reality they aim to represent. They become decontextualised in a morass of memory.

Fox became fascinated by the bizarre pseudo warfare which she found. In its ritualism, aggression and maleness, it was a distorted and magnified version of office life. It was, too, a way of exploring her own position in the patriarchy, of gaining a foothold in a forbidden land:

> It was to do with how I've been brought up. The divisions between men and women in the family. In my family I find it very difficult to speak at times, to have opinions. When I do something like this, I get more of an insight into areas where I'm not allowed to go. [3]

She was shocked and intrigued by the violent intensity of the skirmishes, and when recounting her own experience in the midst of the fighting it is as if the battle were for real. Though the 'weapons' are gas-powered guns which fire only paintballs, the aggression and the tension were nevertheless acute:

> There is no battle noise. You hear the gas cylinders hissing when they run out. But there are these shouting voices. Manic voices. There was one site where there was a World War Two jail block, tunnels and trenches. I went into one Vietcong village where they had a big hut with two layers with a ladder inside it. I started off at the top and when all the people had been shot off there, I moved down to the bottom, then, at the very last moment two guns came out of the holes on either side of my shoulders, and someone let off a smoke bomb, and I knew people were going to start coming in. There was only three feet between me and the door, and I was hoping that they would recognize me, because they shoot you at point blank range in that situation … I lie down flat on the ground. I never run, I just go down. And at the pub afterwards there's a very fanatical post-game conversation. They all look a bit mad. I suppose the whole thing is really a bit mad. [4]

Maniacal shouting, frenzied post-game conversations, confrontations between disguised office workers and garage mechanics – it is a picture of an organized and stratified bedlam in the heart of the English countryside. Even more fascinating and ironical is the fact that fewer 'real' war photojournalists now operate within the battle zone itself, as television crews have now achieved media ascendancy over still photographers. Fox's pastiche war photographs may give us a clearer insight into battle than 'real' war photojournalism is able to do. In Anna Fox's photographs we see many 'dead' combatants; in 'real' war photography we are allowed to see hardly any.

But weekend wargames are, of course, not 'real'. They are a leisure pursuit, played for enjoyment and excitement, drawing on many motifs and styles to produce a suitably seductive arena for reenactment. While real soldiers in combat make use of camouflage to hide them from the enemy, paintball participants use uniform for display and are highly aware of dress codes. Anna Fox has noted that:

Fashion is really important. There are gold guns, anodised guns. You get all sorts of incredible camouflage. And everything has to match. That's very important. Some groups have these amazingly intricate designs – one was really funny – bright purple camouflage, which was ridiculous because it was so pointless. Another team designed its own completely black suits. Some of the designs are very intricate leaf and bamboo patterns. [5]

When Anna Fox began her *Friendly Fire* series at the end of the 1980s, the photographs, notwithstanding Fox's ambivalence towards their subjects, had a bleakly humorous agenda. At one battle site a wooden cut-out model of Margaret Thatcher (*illustrated on back cover*) proved perfect for target practice. Standing against the ragged winter trees of the English countryside, Thatcher gazes at her aggressors with customary *sang-froid*. Her tailored blue suit and chequered silk blouse are splattered with orange paint; she has been shot in the forehead, above the eye, on the cheek and in the heart. Damaged so by those who play the game which her vision of society had made possible, the photograph speaks tellingly not just about the violence of those who play 'paintball' but also about the conflict between gender and power. Women are objects of male aggression and abuse, and Margaret Thatcher remains an enigma, even for her most fervent male supporters. The photograph, styled within a simple documentary frame, makes this point with clarity, and forms an important part of Anna Fox's exploration of this mysterious male world.

We can laugh at the Thatcher photograph, as we can at some earlier images in the series; a man in a snarling monkey mask, two young men relaxing in a pub after the mock battle looking clean and innocent, their smooth hands still recognizably those of the office worker rather than the soldier. They are almost children, still lost in the make-believe games of the playground or the competition of the football pitch. They know, as we know, that it is just a game. But, some two years into the project, Anna Fox's view of 'paintball' began to alter, becoming increasingly bleak and menacing. It began to look like real war.

The sharp focus and revealing flash of the earlier photographs was replaced by something more chaotic, more blurred. Two mock soldiers warily crossing a wooden bridge in the twilight of a winter afternoon no longer look so comic. There is real danger, real fear. The red slime dripping down the walls of a derelict hospital building looks more like blood than paint. One man, hit in the face by an exploding paintball capsule, eyes closed, lips pursed in pain, experiences the collision of skin and bone, the fissuring of blood vessels, the tearing away of surface and the swelling of body fluids. And every so often, a player would catch Fox's eye, and fear and uncertainty became mutual reflections.

Catapulted into this world of men and guns, Anna Fox's once witty documentary of everyday life began to show something more sinister. It became war photography without romance, and she became a correspondent with no glory. The photo series in its reflections on gender and aggression emerges as a discussion of the ambivalence many women feel about the patriarchy, a fascination with its power, and abhorrence of its violence. Gazing at these men, lost in their own fantasies, makes us wonder about the depth of our own imaginings, our own

desires. Objectified in these photographs, paintball players appear as fetishistic objects, guests at a masked ball where identity is lost, appearance mistaken. They are characters in bondage, faces obscured by metal and plastic, hooded and covered, awaiting flagellation and paying for their pain. On the wasted farming grounds of England, these men gain entry to their dreams, become crusaders and warriors, militant saints and avenging angels. Captive in the prison of their own masculinity, they search for significance by the performance of the ancient rites of disguise, ornamentation and bloodletting. With no personal memory of war, they rely instead on a collective one made real by the media of film, photography and television. Soldiers in a private army, they cling to a notion of manhood unsullied by sexual politics, a memory perhaps denied by their experience of the real world.

Equally concerned with the ambivalent nature of masculinity and militarism is Northern Irish artist Moira McIver. McIver's 1992 series *Men In Uniform* is a deeply intriguing body of work, which takes as its theme:

> an exploration of male identity within the military system. The subject was a continuation of a theme I had been examining in previous projects: male identity within public institutions. Although the theme of male identity was my subject matter, it was important for me to find a personal level on which to engage with the work. I have always enjoyed visiting museums. As a child I remember how old military objects in glass cases had a mysterious attraction. Their rich fabrics and intricate braidings and embroidery were seductive. The uniforms evoked hints of a world beyond our present everyday life; a world of mystery and adventure. In adulthood my escapist imaginings are tempered by my realization of the consequences of military 'adventures'. The dilemma which these objects created for me, between seductive mythology and the realities of military warfare was the starting point for my artistic explorations.[6]

Moira McIver's interest in these antique military uniforms provides an important counterpoint to her work on male identity. The peace of the museum contrasts sharply with the violence of battle: passivity and action stand in perplexing juxtaposition. Looking at these uniforms, objectified and institutionalized by their presence in a museum, McIver notices how they had been divorced from any notion of previous ownership:

> During my visits to museums in Belfast and Dublin, I was surprised to find how few uniforms actually had accompanying details about the person who had worn them. In most cases the only information available was the rank and regiment to which the uniform belonged. The uniform's value is primarily as a relic of military history. It seemed perplexing to me that the clothing should carry more historical value than the individual who had worn it. I began to photograph particular sections of the uniforms. By photographing details and then enlarging them, I lost the connection between the clothing and the human figure. The clothing is reduced to shape and colour and becomes flattened and emblematic.[7]

That women should be fascinated by men in uniform is perhaps no strange thing. Uniform, when worn by men in the military, in the police force or in the security services signals strength, masculinity, anonymity and, for some, a particular romance. Men in uniform are no longer individuals, but part of a communal force, their conformity of purpose set against our ragged individualism. In times of war, different forces can be recognized, and can recognize each other, by costume and insignia. Visiting a Palestinian refugee camp in the late 1970s, journalist Robert Fisk observed how the differing guerilla factions were identifiable only by their makeshift quasi-military uniforms:

> Fatah men wore combat jackets, khaki trousers and red berets. George Habash's Popular Front for the Liberation of Palestine were dressed in grubby brown anoraks. Saiqa wore camouflage uniforms, bandoliers or ammunition draped over their shoulders and Palestinian kuffiahs.[8]

Men in uniform are men together, forming allegiances, governed by precise sets of rules and regulations, invulnerable and strong. Their clothing gives them authority, which, in time of war, becomes absolute. The pacifist writer Frances Partridge drew particular attention in her wartime diaries to the way in which uniform changes perceptions of the individual. Towards the end of 1940, she noted that:

> Janetta's brother, Rollo Woolley, now training to be a pilot in the RAF, arrived at tea-time. The effect of his airforce uniform was electric. Burgo[9] was quite flummoxed by it. M.A.M.[10] softened visibly. I think R[alph] and I were also affected … Burgo began dancing round Rollo in a state of hero-worship. M.A.M. wants to provide comforts for him, knit him socks – a strange way it seems to me of blinding oneself to the fact that we are asking this young man to lose his life or be maimed, or at best terribly frightened for the sake of what we want.[11]

Military uniform both challenges and enhances masculinity. When the hero of Evelyn Waugh's 1942 novel *Put Out More Flags* sees his friend Peter Pastmaster in uniform for the first time, he feels a threat to his maleness:

> It came as a shock now to find his country at war and himself in pyjamas, spending his normal Sunday noon with a jug of Black Velvet and some chance visitors. Peter's uniform added to his uneasiness. It was as though he had been taken in adultery at Christmas or found in mid-June on the step of Bratts in a soft hat.
>
> He studied Peter, with the rapt attention of a small boy, taking in every detail of his uniform, the riding boots, Sam Browne belt, the enamelled stars of rank, and felt disappointed, in a way relieved, that there was no sword; he could not have borne it if Peter had had a sword.[12]

All these different reactions are found in Moira McIver's *Men in Uniform*, one part of the photoseries *Subverted Expectations*, where large-scale colour photographs show uniformed men

Seductive Myths 11. From the series Men in Uniform. Moira McIver. 1992.
C-type print 23" x 19". Edition of three. Courtesy of the artist.

posing with some parts of the body (usually the torso and the back) revealed and other parts (notably the face and the hands) hidden. The effect is highly erotic, as skin, pale, exposed and vulnerable is contrasted with the harshness of military clothing and the cold metallic sheen of a regimental badge. As McIver has explained:

> The title *Subverted Expectations* refers to the different viewpoints involved within the image. On one level this young man's expectations of the military may be considered subverted by the institution in that his body and his mental abilities are developed by the organization for their own purposes ... For another male viewer the title implies that traditional notions of the army and the image of the soldier have been subverted by the photograph. The male

viewer is looking at another male body partially naked and on display. This undermines photographic conventions of the active male viewer and the passive female object. This treatment of the male body as an objectified, erotic image may be regarded as a loss of power and a demasculinization. The eroticization of the male body is a difficult viewpoint for heterosexual male culture to accept … For the female viewer, her position within the camera power gaze structure is reversed and she is placed in a position of power.[13]

It is unusual for photographers and artists to create a public dialogue with those they have portrayed. In fashion spreads, models have only recently begun to be credited and we rarely hear their opinions about the way they have been represented. Unless they are celebrated in their own right or perhaps as family members, women photographed by men frequently appear anonymously, as objects rather than people. Moira McIver, conscious of this objectification, subverts art historical and public expectations by interviewing her model, former sailor Geoff Nelson, about his feelings about the photograph she made of him (see front cover photograph). Nelson remarked on his portrait:

I think it's definitely sensual, because it is part of a body. If the face was included, you'd probably concentrate more on the face and disregard this bit. But because the face has been cut out you focus on this piece of flesh. It's an area which you wouldn't normally see. In the military, if you wear a uniform you wear it properly fastened up.[14]

I think if my face had been in it – if the image hadn't gone down too well and people were making comments or making a dig at it, then I think I would have been a little bit hurt. Because it is anonymous I wouldn't really mind what people said about it … The back could be anyone's. I don't look at it and think 'that's my back'. I know it's me but I just look upon it as a photograph. I think if it had included my face I would have looked upon it differently because it would be a direct connection to me.[15]

While McIver's photographs subvert our expectations of portraits of military men, other assumptions are also confounded. Geoff Nelson did not believe that by obscuring or omitting his face, McIver had objectified or fetishized his body, but rather had given him a reassuring anonymity. For many women, being photographed in this way would represent disempowerment. For Nelson, as a man and representative of a gender whose bodies are infrequently fetishized through erotica, the agenda was radically different.

Women's reactions to *Subverted Expectations* clearly acknowledge the erotic nature of McIver's photographs. Fellow artist Amanda McKitterick observed:

It's erotic to see someone unclothed and because there are some clothes and then no clothes there, he seems unclothed. It doesn't matter that it is not his genitals or even the tops of his legs or somewhere near his genital zone. Because it's his bare flesh next to his unbareness and because we're looking, we're aware of looking at him and he is aware of being looked at. So it's partly to do with examining him. There is also a certain amount of power. I mean, that

person can't take that back, so they've exposed themselves, you are now in control, he can't stop you looking. So I think that is part of the eroticism of it.[16]

Subverted Expectations deals with sexuality, with the fetishization of costume, with voyeurism and the ambivalent relationship between the portrayer and the portrayed. It involves a study of the female gaze and the subsequent objectification of the male body, and notes the ways in which our reactions to photography are conditioned by an appreciation of context and circumstance. In her series *Seductive Myths* 1,2, *and* 3, in which an elderly man is photographed wearing a rich, red antique military uniform, McIver confronts other issues, quite clearly those of a male sexuality challenged by increasing age. Of these photographs, McIver writes:

> I wanted to echo the romantic, cinematic images of the traditional male hero; the swashbuckling adventurer. The images are rich and sensual and the model's long white hair and beard complete the sense of period and history. Yet the man in these photographs is obviously older. His older body and his pose suggest his human mortality. His anonymity makes him symbolic.
>
> I wanted to create a tension between the myth of the invincible male hero and our knowledge of the inevitability of ageing and death.[17]

In her photographs, McIver has made many connections between the past and the present, our sense of history and our perception of our own contemporary times. As a Scottish woman living in the Northern Irish cities of Belfast and Derry from the early 1980s, she was highly aware of the complex political and military situation in Northern Ireland. Writing an overview of *Men in Uniform*, she notes that:

> My own experience of seeing soldiers patrolling the streets of Belfast also had a strong influence on my perceptions of the uniforms. Ironically, the 'camouflage' uniform worn by soldiers actually marks them out very clearly in a city environment. It separates them from the civilian population and highlights them as potential targets. Passing by a patrol of soldiers my emotions vary from anger to empathy. I feel anger at being made to feel vulnerable. I have this inner anxiety that my chances of being involved in an attack dramatically increase when I am close to a patrol. My reactions to the soldiers themselves sometimes vary. At points I feel anxiety for young people who join the forces because of limited opportunities; at other moments I cannot understand why people want to become involved with an organisation which puts them into situations of danger.[18]

Both Anna Fox's *Friendly Fire* and Moira McIver's *Men in Uniform* are inquisitive forays into territories made problematic by sexual politics. Both document and explore fantasies, female and male, ours and theirs. While Anna Fox does not pose her subjects, to a great extent they pose themselves, as they engage in a game of make-believe. When the 'soldiers' she photographs die in battle, they are able to pick themselves up from the ground and begin again, and at lunchtime, the war stops. They play for points, rather than for nations, Their

battlegrounds are a pastiche of the past, and their reenactment of history is full of error. Moira McIver asks the men she photographs to be interpreted by her gaze, by her perceptions of history and her relationship to the current events which surround her. She invites us, as her audience, to make our own connections with now and then, the real and the imagined, and the perplexing area which lies between.

In 1991, New York photographer Barbara Alper began to photograph the Gulf War from the subtitled news reports of the French television company Antenne 2. Alper's series, *Gulf Channel*, a set of colour photographs made directly from the TV screen, examines the ways in which this strangely surreal war was conveyed into our homes. A significant work on many levels, it confronts the phenomena of war as spectacle, acknowledging that many people in Europe and the USA became fixated by its news coverage, with its high-tech weaponry and bizarre

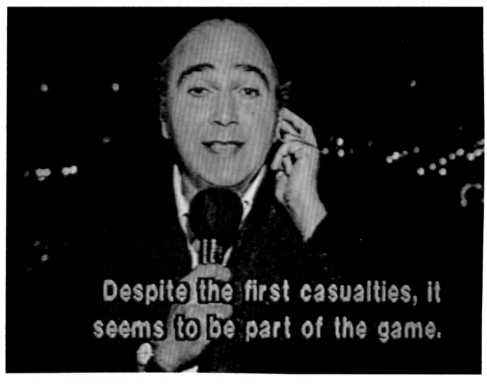

From the series Gulf Channel. Barbara Alper, 1991. C-type print. Courtesy of the artist.

pyrotechnics. The propaganda which led up to the Gulf War had cleverly presented the Iraqi state as an emerging superpower – many comparisons between Saddam Hussein and Adolf Hitler were made by the press at the time – and had profiled the war as a major conflict between the moral rectitude of western democracy and the evil of the Islamic police state. Little mention was made of the vested European and US political and economic interests in the disputed territories. Access to the war by correspondents, particularly photographers, was tightly controlled. Photographic evidence of NATO forces' actions, such as the wholesale

massacre of civilians and militia on the road to Basra at the end of the war, were largely hidden from the British public through tacit agreement between the media and government sources. By contrast, during the current conflict in Bosnia, where western forces act as 'peacekeepers' rather than combatants, photographers have been given much easier access to the war zones.

Within the context of this carefully managed news coverage, Barbara Alper made *Gulf Channel*. Her previous work, and that for which she is best known, was a lengthy and ongoing study of New York sex clubs – another world of secrets. The two projects have important similarities: the subjects of both rely on disguise and role playing, both are highly exciting, both operate clandestinely. Seeing the Gulf War acted out, via the television screen, in the privacy of her home, Alper was perhaps making connections with the voyeurism implicit in her earlier sex pictures. Watching other people making war is perhaps as questionable as watching other people having sex. That most war photographers would disclaim this is taken as read. The significance of Alper's work is that she acknowledges the excitement of the act of looking.

But *Gulf Channel* also has a particular political agenda, and Alper observes that:

> This series shows the stupidity and uselessness (as well as displaying how macho each country is) of war and the agony it puts people through. I've always been a 'peacenik', joined the strikes and demonstrations on campus during the Vietnam war, generally been opposed to fighting and killing as a way of working out one's problems … Something else that came out of this work is a commentary on the media and the way it influences our thinking, our attitudes, and our decision-making processes. We rely on TV for news and it's all too easy to accept what is presented to us as objective, as 'fact' … without knowing who is behind their 'slant', what the TV stations have at stake because of who owns them, who their sponsor is, etc … We need to learn to question not only our governments … but also the people who present the information to us, and to be aware of how we are being manipulated by all of them.[19]

Gulf Channel is an intriguing combination of image and text. One bizarre photograph shows a war correspondent looking like a vaudeville host, speaking to the cameras of the Antenne 2 crew, with the subtitled caption (translated from French for American viewers) reading: 'Despite the first casualties, it seems to be part of the game.' Divorced from the original context of the transmission, we are left to consider this text in relation to the image which accompanies it. It is as if the reporter were collusive in the enactment of this eerie scenario: acknowledging its status as 'game', the piece calls into question the morality of this war. Another photograph shows a missile lying on its side on the ground. The location is unidentifiable, and the caption reads laconically: 'Any suggestion that wars kill and injure is censored.'

Gulf Channel is a comedy of language and picture in which irony is laid upon irony. Television projects war into our homes as it happens – no longer do we have to wait for photographs to be sent to newspapers, and for the printed page to be processed. But nevertheless, the 'reality' beamed into our homes is a fantasy, constructed by political ambitions and nationalistic bias.

Jumbled among all the other dramas that TV brings, war becomes just another plot, another set of characters. We, as audience, become spectators and consumers of something which seems hardly to touch on our own lives.

Moira McIver, Anna Fox and Barbara Alper are war reporters of a new and singular kind. With fascination and inquisitiveness, they have peered into worlds which are alien to them, but which they find deeply intriguing. In doing so, they set new agendas, pose new questions about a myriad of issues which must concern us all. They inquire into questions of gender and sexuality, and ponder on the uses of new and powerful technologies. In their work, war is no longer a distant game played outside the realms of our experience, but rather something which is near to home, possessed of an uncanny domesticity. Looking into this man's world, these three photographers have constructed dark and intricate comedies of manners and morals, sagas for the end of the century.

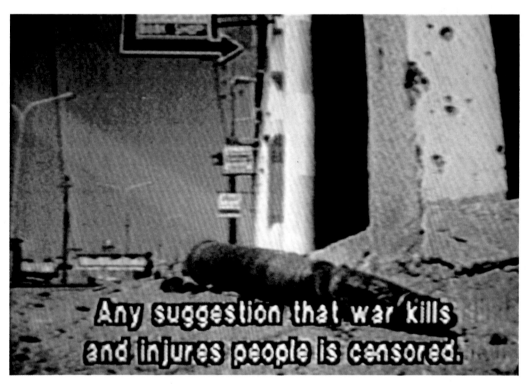

From the series Gulf Channel. Barbara Alper, 1991. C-type print. Courtesy of the artist.

Notes

Chapter One LANDSCAPE REVISED: *The Rural Iconography of the First World War*

1 Quoted from *Testament of Youth*, Chapter VIII, 'Between the Sandhills and the Sea', 1933, pp.371ff.
2 Now reprintrd in *Illuminations*, edited by Liz Heron and Val Williams, Jonathan Cape, 1994.
3 Letter to the author, 19 September 1992.
4 *ibid.*
5 Battle of Britain Prints International, London, 1976.
6 *ibid.*
7 *ibid.*
8 'Of Mother Nature and Marlboro Men', Deborah Bright, 1985.
9 Elizabeth Williams papers. 1994
10 *ibid.*
11 *ibid.*

Chapter Two SHADOWS ON THE BODY: *Photography and the Holocaust*

1 During the 1993 symposium *Krieg*, Graz, Austria.
2 I am grateful to Alan Dein for drawing this to my attention.
3 *Observer Magazine*, London, 30 January 1994.
4 *ibid.*
5 *ibid.*
6 *ibid.*
7 *Wrens in Camera*, Hollis and Carter, London, 1945.
8 Lund Humhpries, London, 1941
9 *Lee Miller's War*, edited by Anthony Penrose, Conde Nast, 1992. p.161.
10 *Margaret Bourke-White: A Biography* by Vicki Goldberg, Heinemann, London, 1987.
11 *ibid.*
12 *Dear Fatherland, Rest Quietly* by Margaret Bourke-White, Simon and Schuster, New York, 1946.
13 *Portrait of Myself* by Margaret Bourke-White, Collins, London, 1964.
14 Methuen, London, 1988.
15 *ibid.* p.425.
16 *The Holocaust: The Jewish Tragedy* by Martin Gilbert, Fontana, London, 1987, p.361.
17 *Five Chimneys* by Olga Lengyel, Mayflower Books, London, 1972, p.30.
18 *If This is a Man* by Primo Levi, first published in Italy, 1958. This edition, Abacus, 1990, p.33.
19 *Voices of the Holocaust*, compiled and edited by Carrie Supple and Rob Perks, British Library National Sound Archive, London, 1993.
20 *ibid.*
21 *The Holocaust: The Jewish Tragedy*, op cit., p.198.
22 *Those Were the Days: The Holocaust as Seen by the Perpetrators and Bystanders*, edited by Klee, Dressen and Weiss, Hamish Hamilton, London, 1991, p.32.
23 *ibid.*, p.xi.
24 *ibid.*, p.xvii.
25 *ibid.*

Chapter Three THE MYTH AND THE MEDIA: *Photography and the Vietnam War, 1968-1992*

1 *Shooting War* by Susan Moeller, Basic Books Inc., New York, 1989.
2 *Margaret Bourke-White: A Biography, op cit.*
3 *Nova Magazine*, May 1968, p.64.
4 *ibid.*
5 *Vietnam Inc.* by Phillip Jones Griffiths, Collier Books, New York, 1971.
6 *ibid.*
7 *Granta*, 1991.

8 *Dispatches* by Michael Herr, Alfred A.Knopf Inc., 1977.
9 *ibid.* pp.15-6 from the Pan edition.
10 *Page After Page* by Tim Page, Sidgwick and Jackson, London, 1988, p.111.
11 *News and Views of War* by Martha Rosler in *Krieg, Camera Austria*, Graz, 1994.
12 Art in America.
13 In *Krieg*, published by *Camera Austria*, 1994.
14 *Real Faces* by Max Kozloff, Whitney Museum of American Art, New York, 1988.

Chapter Four THE UNREDEEMED PAST: *Enigmas of Collective Memory, 1980-1992*

1 Masumi Hayashi, unpublished papers.
2 Using, among other sources, Brian Niiya's *The Japanese American National Museum Encyclopaedia of Japanese American History*, New York, 1993.
3 *ibid.*
4 For a survey of work made by US photographers at this time, see *Executive Order 9066: The Internment of 110,000 Japanese Americans* by Maisie and Richard Conrat, California Historical Society, 1972.
5 'Work in Progress: Audio Work', Masumi Hayashi papers, 1993.
6 With the designer and photographer Rosie Martin.
7 On the occasion of her 1993 exhibition *Innocence is No Protection* at the Edge Gallery, London. Press release.
8 *For God, Country and the Thrill of It* by Anne Noggle, University of Texas Press, 1990.
9 *ibid.*
10 *ibid.*
11 *ibid.*
12 Letter to the author, 1992.
13 *For Palestine*, Zed Books, London, 1985
14 *Beirut*, Thames and Hudson, London, 1984
15 *Aftermath* by Sophie Ristelhueber, Thames and Hudson, London, 1991. Sophie Ristelhueber's Gulf War photographs were shown at the Imperial War Museum, London, in the same year.
16 *British Photography: Towards a Bigger Picture*, Aperture, New York, 1988
17 *Outer Space*, exhibition catalogue, South Bank Centre, London, 1992.

Chapter Five IT'S A MAN'S WORLD: *Photography, Fantasy and Fetish in the 1990s*

1 By Anna Fox, *Camerawork*, London, to coincide with Anna Fox's exhibition.
2 In conversation with the author, 1991.
3 *ibid.*
4 *ibid.*
5 *ibid.*
6 Moira McIver to the author, 1994.
7 *ibid.*
8 *Pity the Nation* by Robert Fisk, Andre Deutsch, London, 1990. This quote taken from the Oxford University Press edition, 1991, p.103.
9 Burgo Partridge was the only child of Frances and Ralph Partridge.
10 Mother of Frances Partridge.
11 *A Pacifist's War* by Frances Partridge, The Hogarth Press, London, 1978.
12 *Put Out More Flags* by Evelyn Waugh, Chapman and Hall, London, 1942.
13 Moira McIver papers, undated.
14 Geoff Nelson in conversation with Moira McIver. Unpublished papers, undated.
15 *ibid.*
16 Amanda McKitterick in conversation with Moira McIver. Unpublished papers, undated.
17 Unpublished papers, 1992.
18 Letter to the author, 23 September, 1992.
19 Letter to the author, 1993.

Index

Barbara Alper

Val Williams was born in the West Midlands. She studied English and American Literature at the University of Kent, and was the founder-Director of Impressions Gallery in York. Since 1981, she has worked as a writer and curator in London. In 1986, she curated the exhibition *Women's Photography in Britain 1900-1950* for the National Museum of Photography, Film and Television. Recent curatorships have included *Who's Looking at the Family?* (1994) for the Barbican Art Gallery, London and *Warworks: Women, Photography and the Art of War* for the Nederlands Foto Instituut and the Victoria and Albert Museum, London. In 1989, she initiated the *Oral History of British Photography* with the British Library National Sound Archive.

She is the author of *The Other Observers: Women's Photography in Britain 1900 to the Present* (Virago 1986) *Ida Kar: Photographer* (Virago 1989); *Who's Looking at the Family?* (Barbican Art Gallery 1994) and is the co-editor of *Illuminations: Women Writing on Photography 1854 to the Present* (Jonathan Cape 1994). Catalogue texts have included *Flogging a Dead Horse: Photographs by Paul Reas* (Cornerhouse 1993); *Under the Hood: Photographs by Chris Harrison* (Viewpoint Gallery 1994) and *Mari Mahr: A Collection of Photographs* (National Museum of Photography 1994).

Val Williams writes on photography for publications which have included the *Guardian*, *Independent*, *Telegraph Magazine*, *Creative Camera* and *Women's Art*. She is a founding member of the Signals Festival of Women's Photography.

Val Williams lives in London with her two daughters.